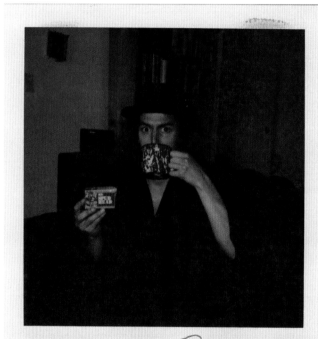

who me?

OF POTATO HEADS AND POLAROIDS

MY LIFE INSIDE AND OUT OF PEARL JAM

Mike McCready

pH **powerHouse Books**

Brooklyn, NY

As Pearl Jam fans, we've all seen it: Mike McCready on stage with a guitar in one hand and his Polaroid camera in the other. He has a guitar pick in his mouth and a big smile on his face as he clicks the shutter, spits out a Polaroid of the cheering crowd, places the camera on his amplifier and turns the volume knob back up on his Telecaster.

Music and life are unpredictable, kind of like Polaroids. Some moments are amazing, some are epic failures and many are what we call happy accidents.

So one never knows what you might get on any given day of your journey. If you are Mike McCready, you have a very interesting journey, and your "family" is massive. This diary of his life on the road shares his family with all of us.

And don't be surprised if you look through one of these pages and spot yourself grinning into his camera.

· Danny Clinch

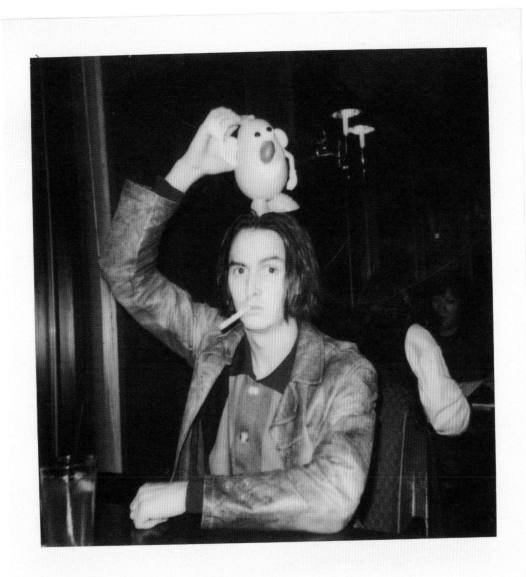

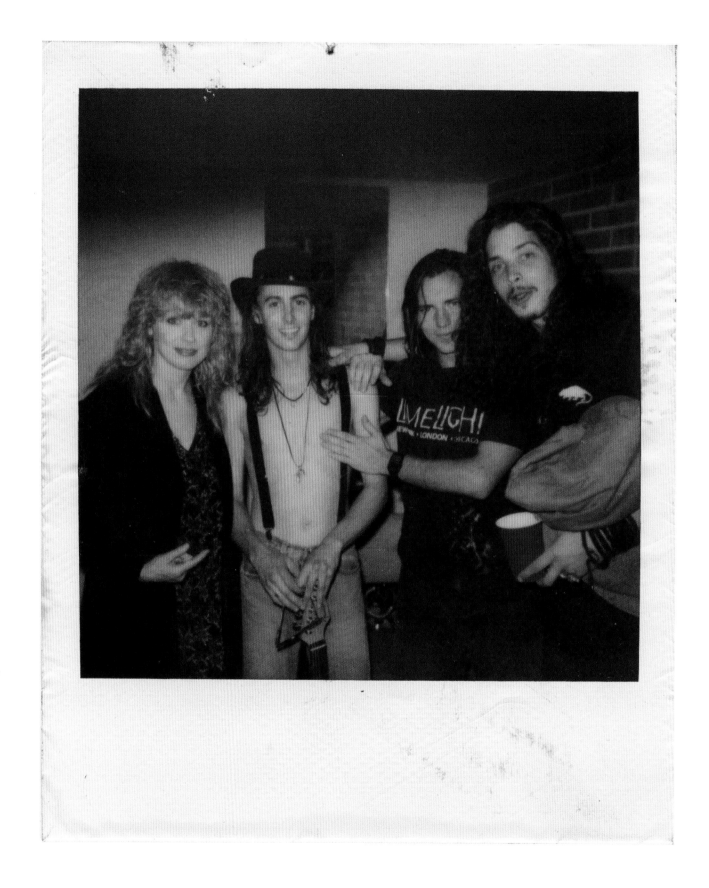

NANCY WILSON, MIKE McCREADY, EDDIE VEDDER, CHRIS CORNELL

Why Polaroids? I have always liked the immediacy and tangibility of Polaroids. In this world of moment-to-moment media distractions, Polaroids can be an anchor to another time, when life was simpler and moved a little slower...

Relinquishing control and letting things happen organically has led to some of the best Polaroids in my collection. On the flip side, having a preconceived notion of how a shot should look and spending a lot of time setting it up has led to disappointment... Much like life as a whole—if I just let go, it often works out better for me.

My earliest memories of Polaroids were on my grandparents' boat in Seattle in the mid 70s. My grandma, Ina, had an SX-70 and I remember her being very careful of how many shots were taken because the film wasn't cheap. I remember her taking a lot of family shots during the holidays.

Why Potato Heads? In 1994, I was in Minneapolis and was browsing a drugstore when I saw a Mr. Potato Head on the shelf. On the box it said, "It's Fun!" I thought, "Fuck it, this probably is fun!" So I bought it. Within a couple days I wondered why I bought it, but quickly decided to start taking Polaroids of it. Other than myself, John Baker Saunders from Mad Season was the first person to take a picture with the Mr. Potato Head.

Some of my favorite Polaroids with some of my favorite artists include Neil Young, The Ramones, Tom Petty, Cheap Trick, Jello Biafra of Dead Kennedys, and my friends in Soundgarden. During the 2014 European tour, I took pictures of Stonehenge, the Duomo in Milan, and the Brandenburg Gate with 20-year-old discontinued and expired film that I found stashed away in my old storage locker. I was surprised how great they turned out!

I would estimate that I've taken nearly 20,000 Polaroids in the last 25 years and sifting through them during this process has brought back a lot of great memories. I'm thrilled I can share even a portion of the shots with you. I hope you enjoy this journey through synthetic plastic images with me...

· Mike McCready

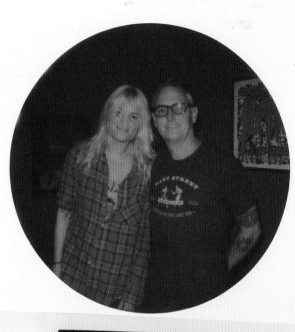

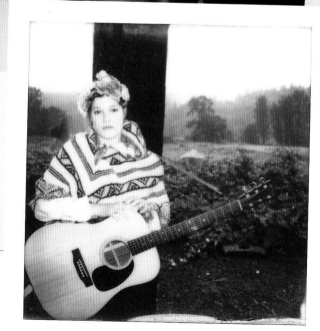

ALISON MOSSHART / STAR ANNA
DAN PETERS / JOHN BAKER SAUNDERS
MARK ARM, EDDIE / STAR

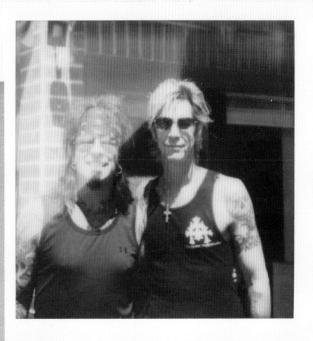

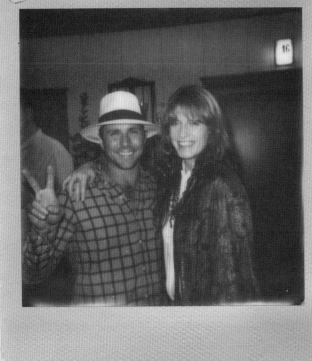

NEIL YOUNG / NANCY
CRAIG GASS / NIKKI SIXX, DUFF McKAGAN
LUKAS NELSON, FLORENCE WELCH

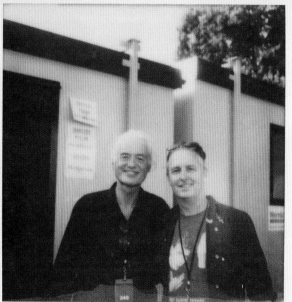

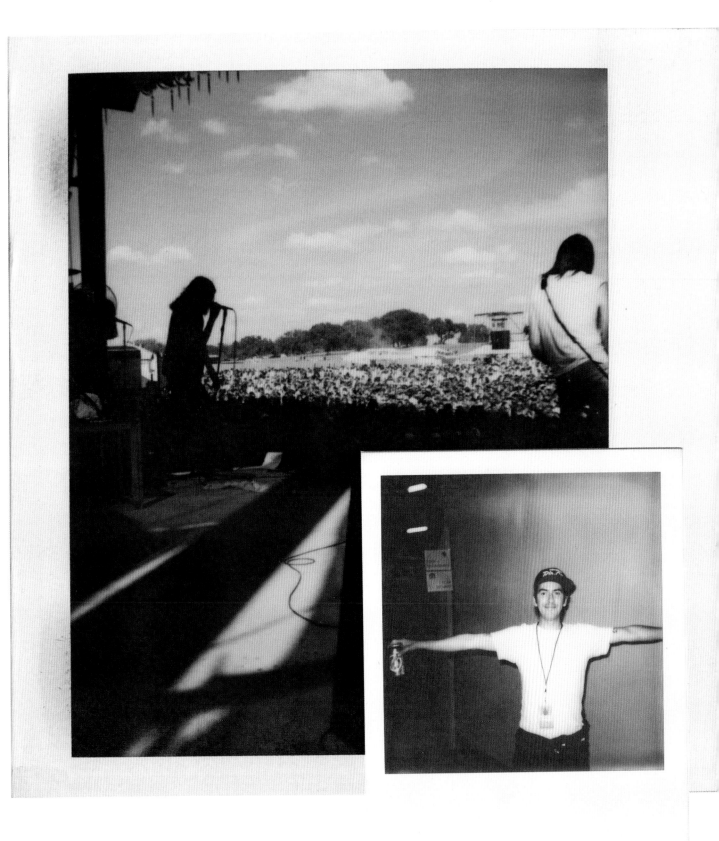

< MATT CAMERON, MIKE BORDIN / GARY WESTLAKE
< ROBIN ZANDER / JIMMY PAGE
< RICK NIELSEN / MATT, BEN SHEPHERD

JOEY RAMONE, JOHNNY RAMONE
DHANI HARRISON

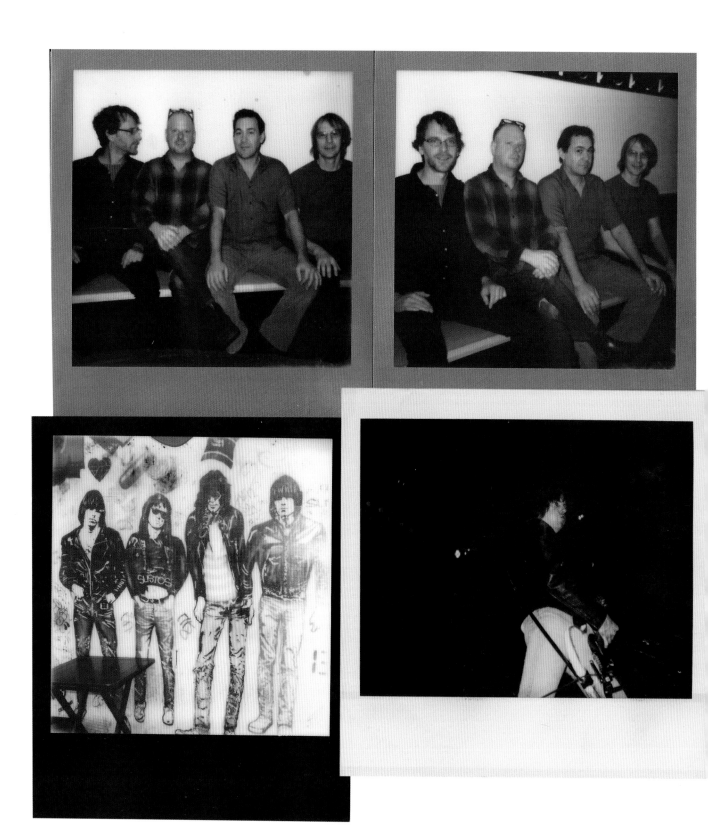

STEVE TURNER, DAN PETERS, GUY MADDISON, MARK
JOHNNY

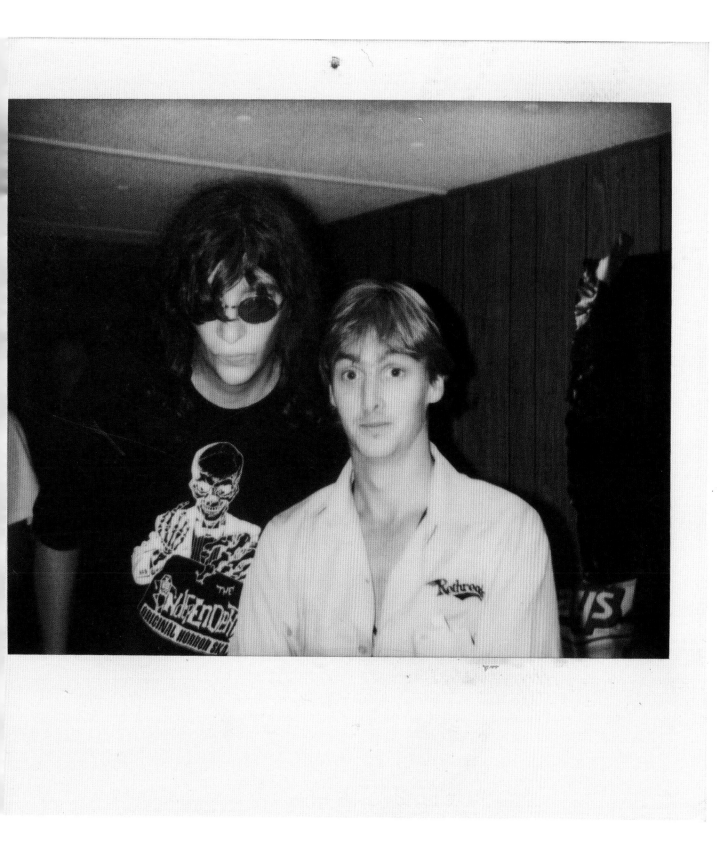

JOEY

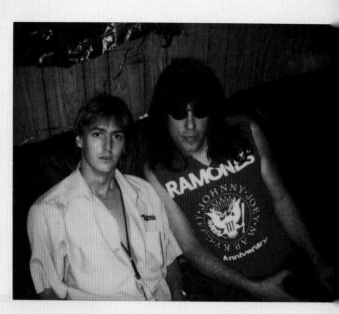

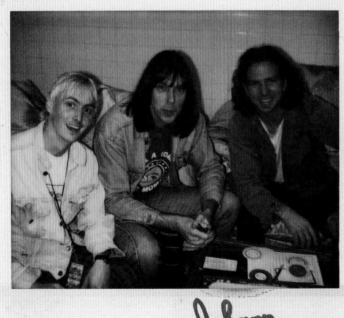

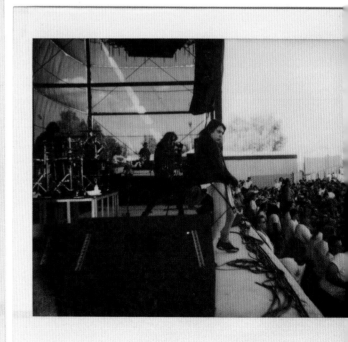

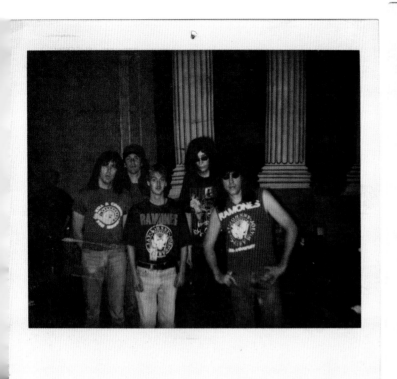

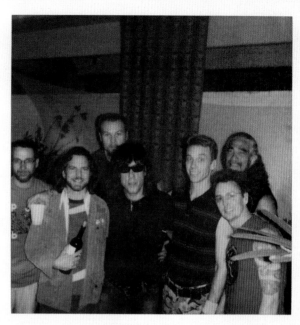

Two staples of the Seattle music scene
that I always love running into

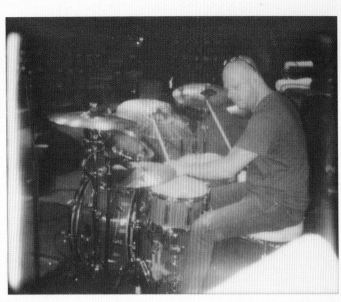
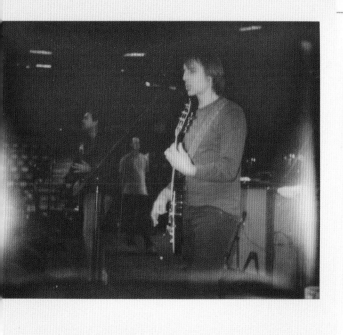
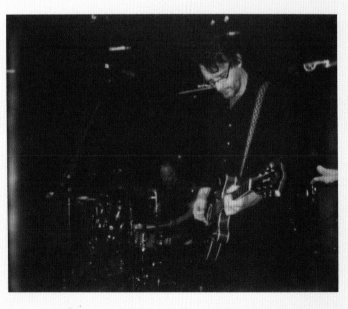

MARK, KIM THAYIL / DAN
MARK / STEVE

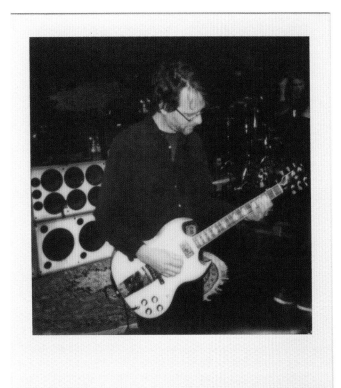

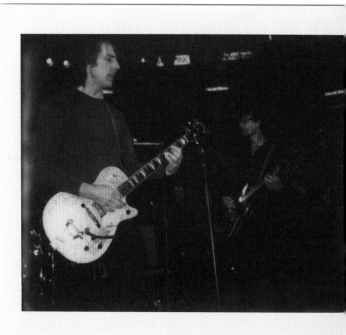

STEVE / MARK
GUY / SOUNDGARDEN

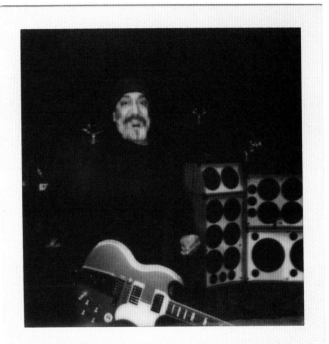

KIM

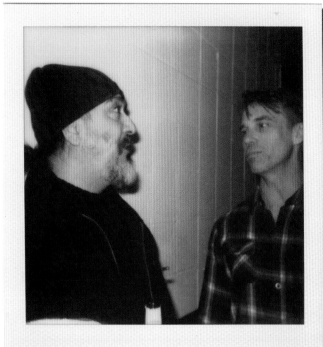

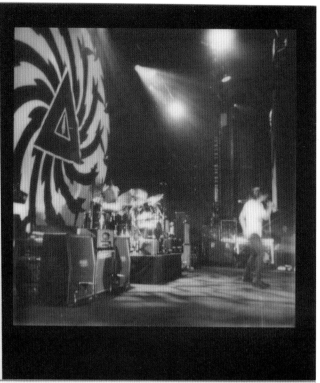

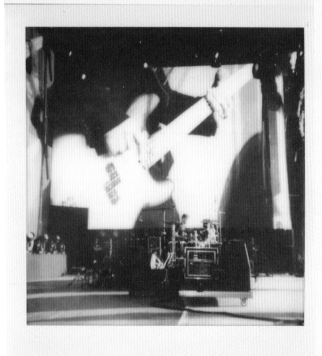

BARRETT MARTIN

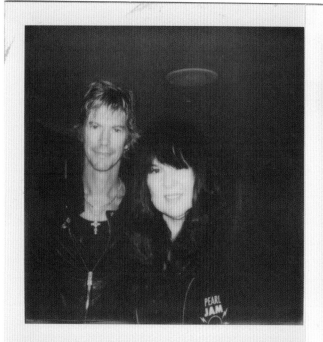

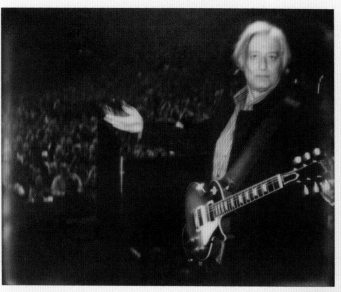

DUFF, ANN WILSON / PETER BUCK
EDDIE / BAKER

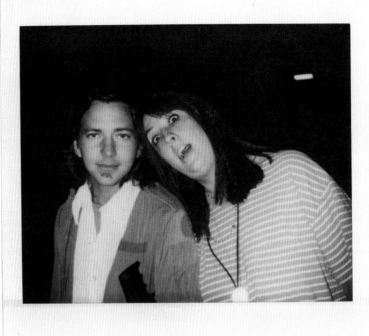

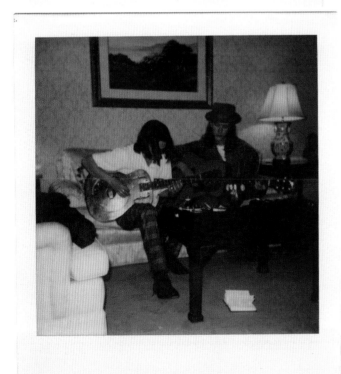

STAR / EDDIE, KIM WARNICK
PETE DROGE / BEN HAGGERTY, RYAN LEWIS

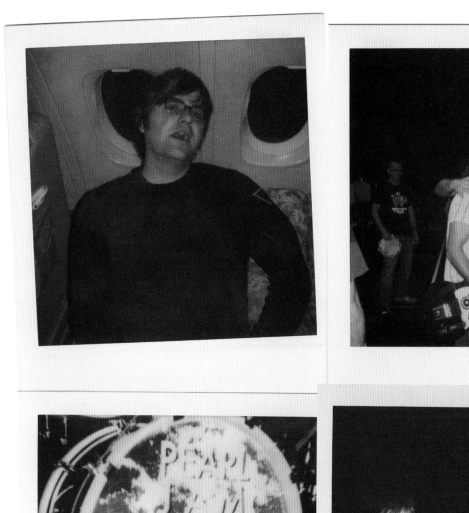

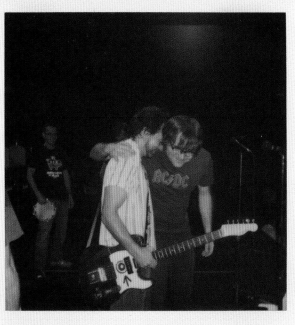

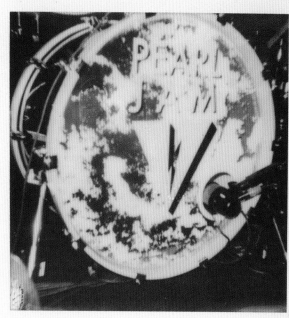

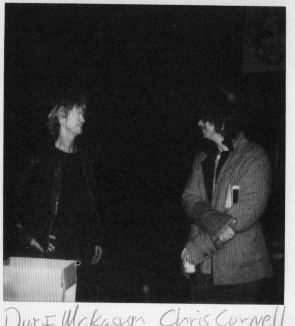

Duff Mckagen Chris Cornell
Mad Season Symphony
Rehearsal

BEN GIBBARD / EDDIE, BEN
DUFF, CHRIS

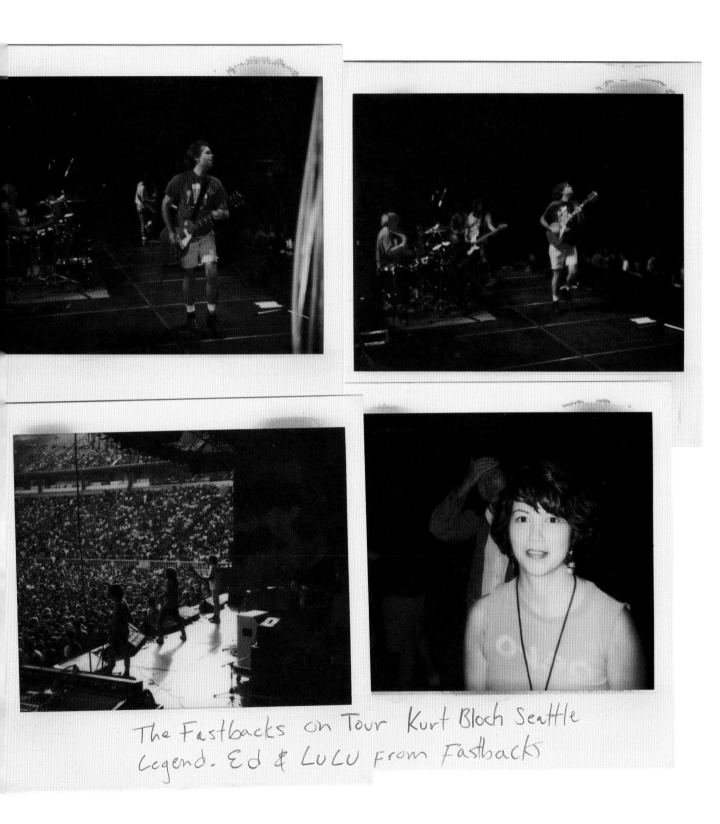

The Fastbacks on Tour Kurt Bloch Seattle
Legend. Ed & LULU From Fastbacks

KURT BLOCH / LULU GARGIULO

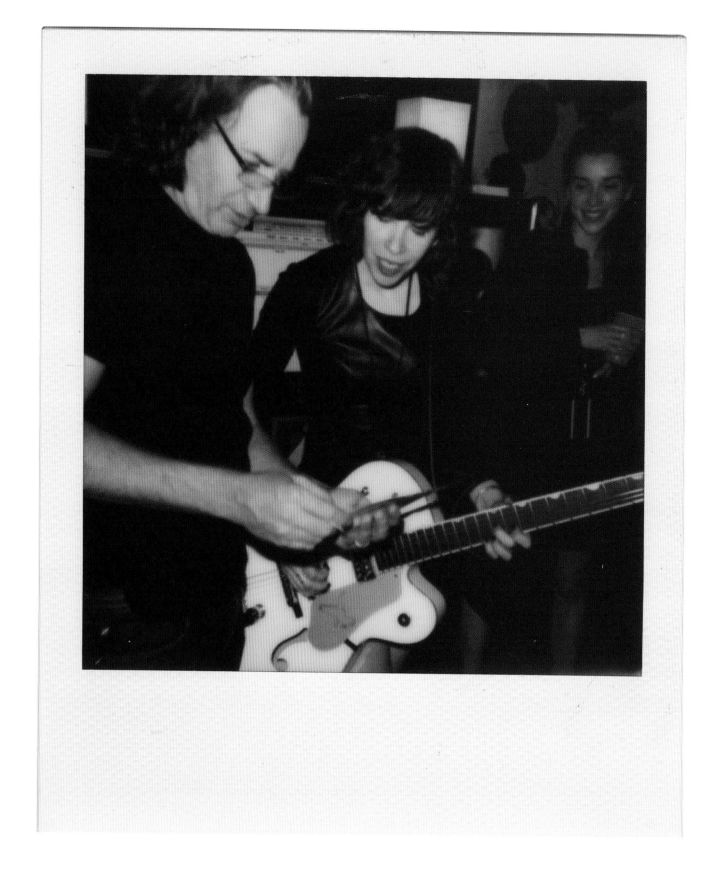

STONE GOSSARD, CARRIE BROWNSTEIN, ANNIE CLARK

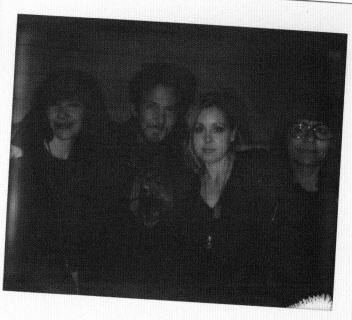

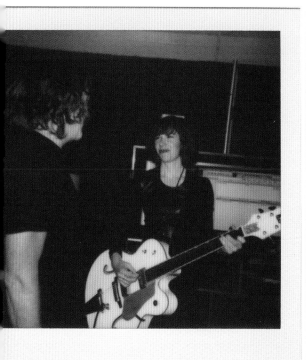

STONE, CARRIE / CARRIE, EDDIE, CORIN TUCKER, JANET WEISS
STONE, CARRIE / CORIN, CARRIE, JANET

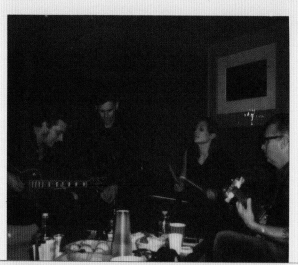

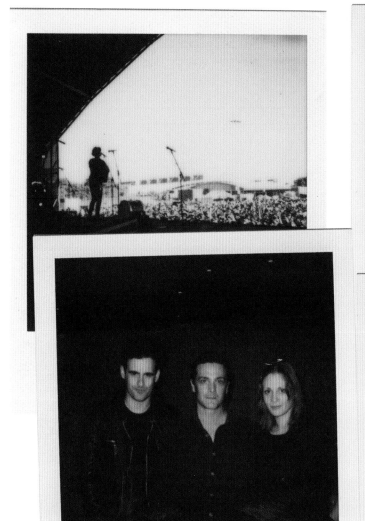

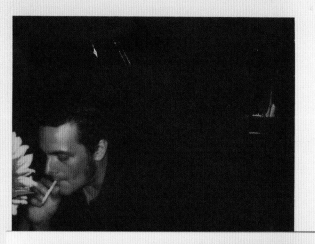

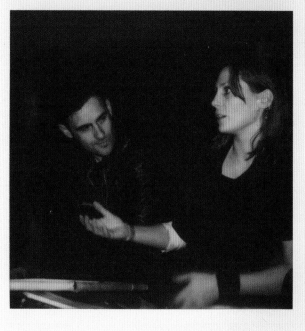

BLACK REBEL MOTORCYCLE CLUB

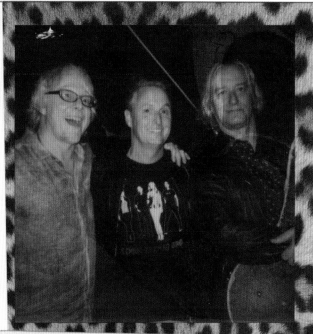

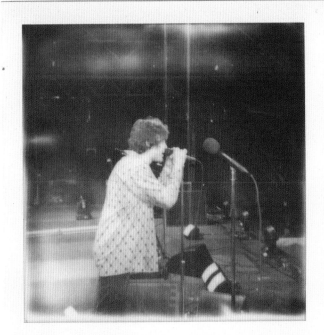

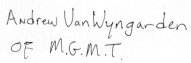

Andrew VanWyngarden
OF M.G.M.T.

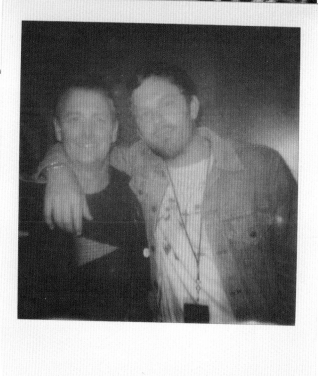

IAN MACKAYE / MIKE MILLS, PETER
ANDREW VANWYNGARDEN / CALEB FOLLOWILL

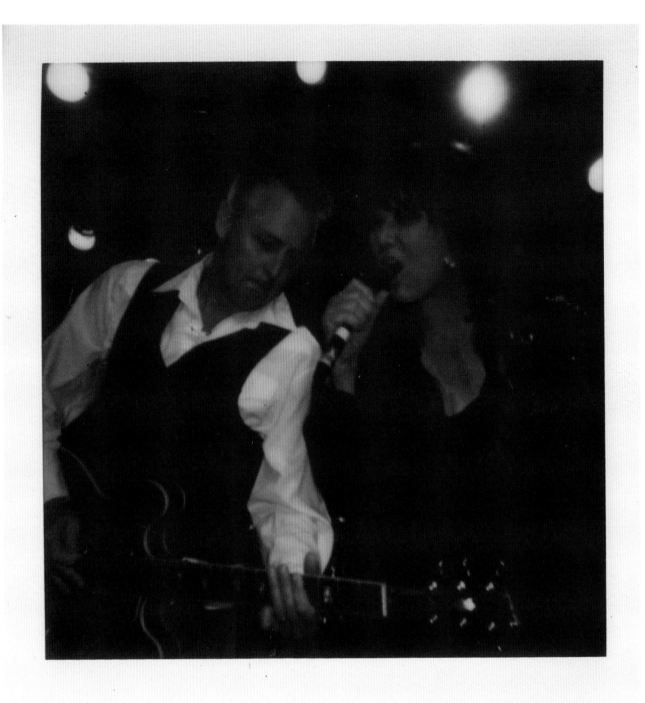

Led Zeppelin Tribute at Flight to Mars

ANN WILSON

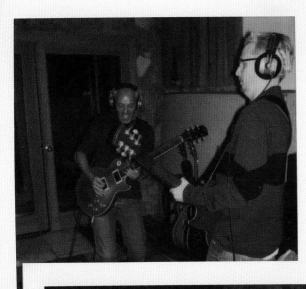

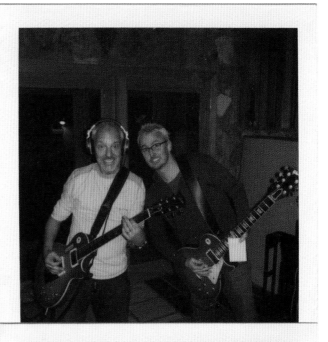

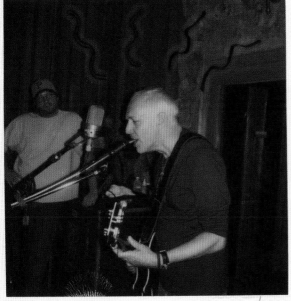

Recording an Instrumental
Version of
Black Hole Sun

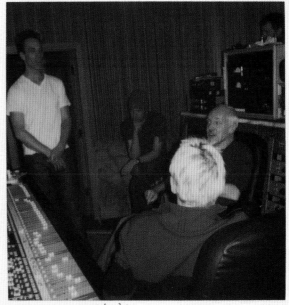

Matt Cameron
Peter Frampton
Gary Westlake

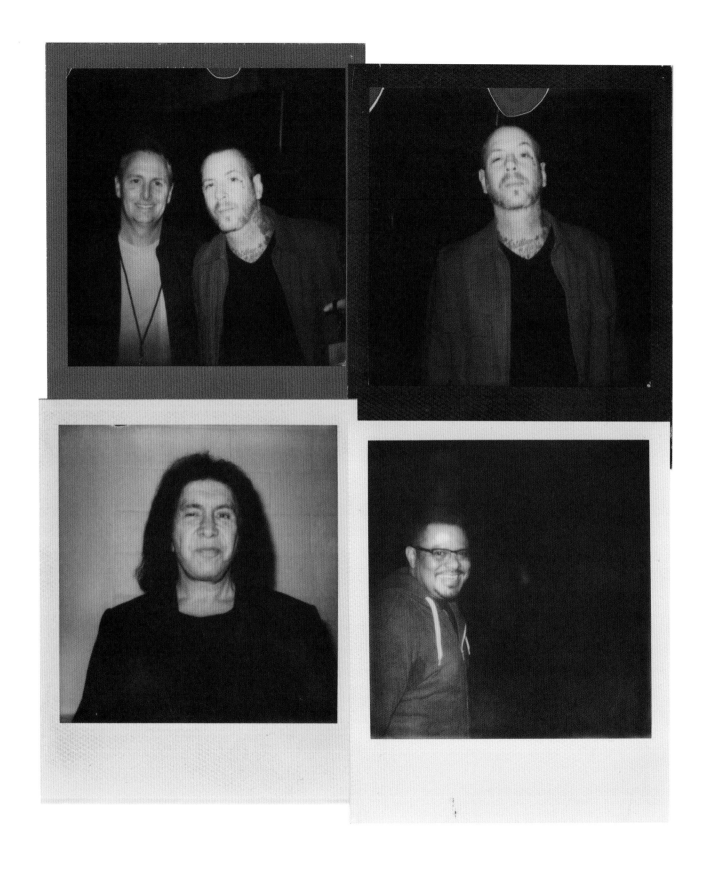

MIKE NESS
GENE SIMMONS / JESSE CALLEROS

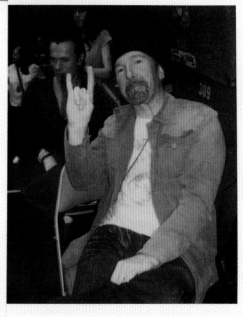

DAVE GROHL
BONO / LARRY MULLEN JR, THE EDGE
WIN BUTLER

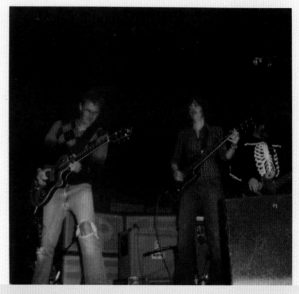

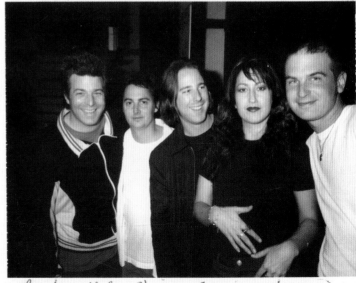

PAUL McCARTNEY'S BASS, MY '56 STRAT
WITH SLEATER-KINNEY
BILL WIXEY, RICK, RICK / RICK
THE ROCKFORDS

Rick, me (Chris) Carrie akre, Dann

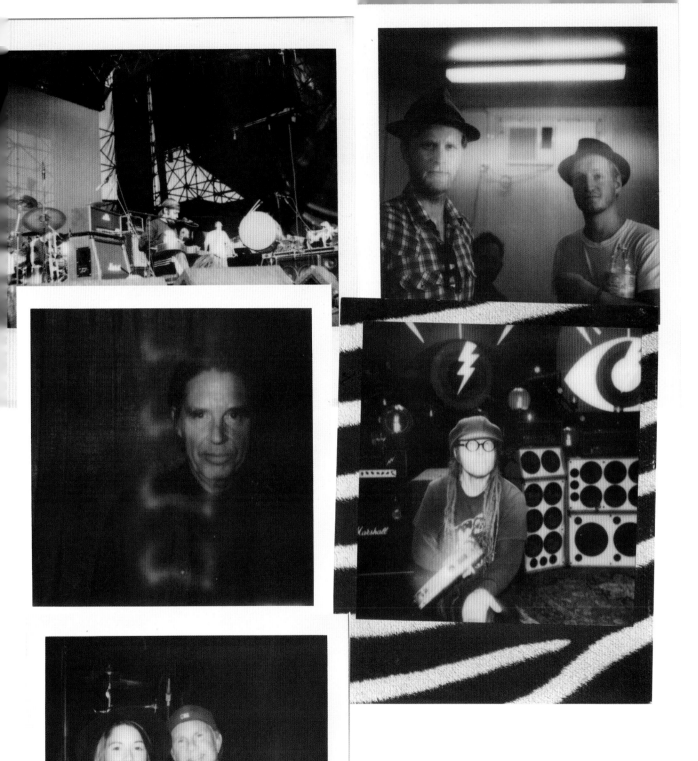

BEN HARPER / WESLEY SCHULTZ, JEREMIAH CALEB FRAITES
JOHN DOE / KEITH MORRIS
BRANDI CARLILE, CHAD SMITH

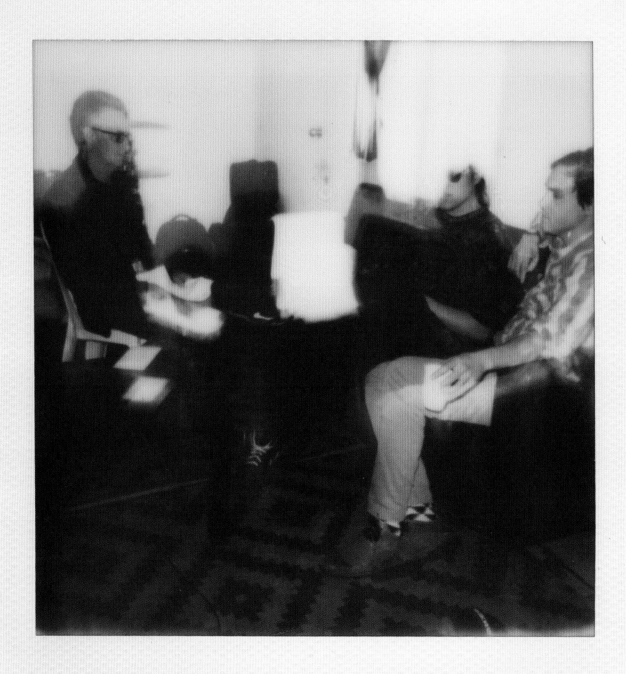

Interview with Win & William Butler Of Arcade Fire For Pearl Jam Radio

WIN, WILLIAM BUTLER

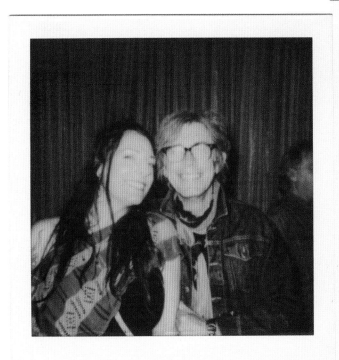

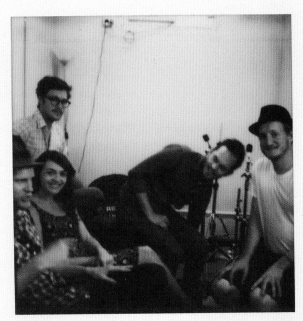

CYNTHIA HOWELL, TOM PETERSSON / THE LUMINEERS
ANNIE / STEFAN LESSARD

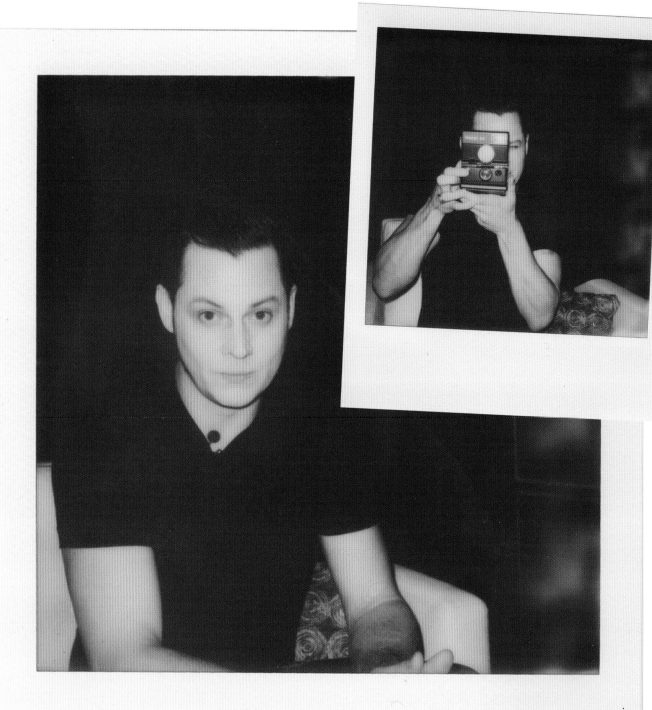

Jack sat down for an interview and brought his Polaroid 960

JACK WHITE

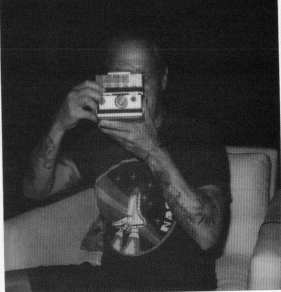

Photo by
Jack White!

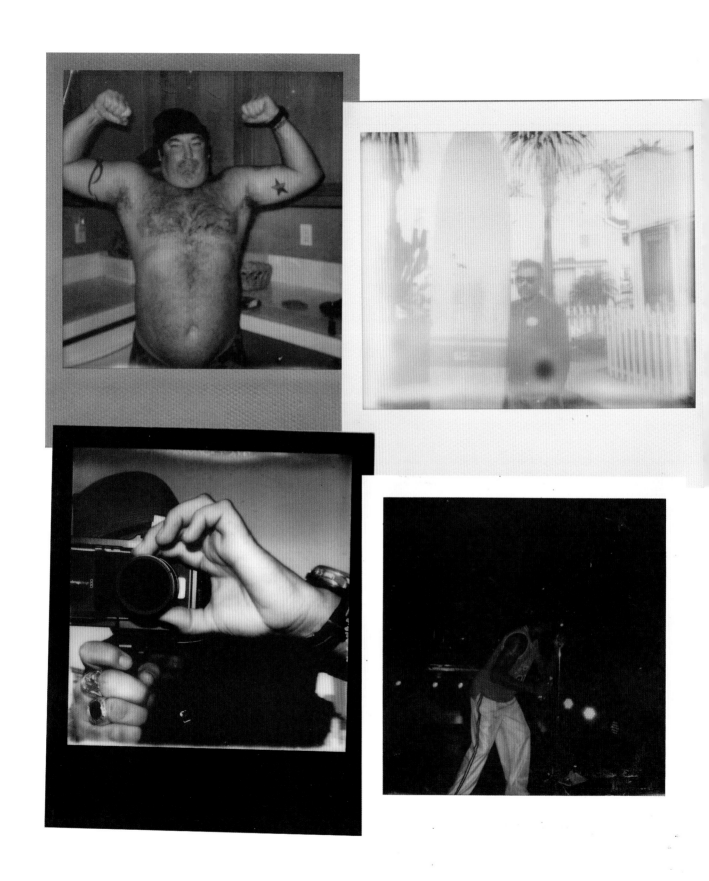

MIKE WELLS / MIKE DE LA CRUZ
DANNY CLINCH / DENNIS RODMAN

Cancer For College
Benefit Will Ferrell

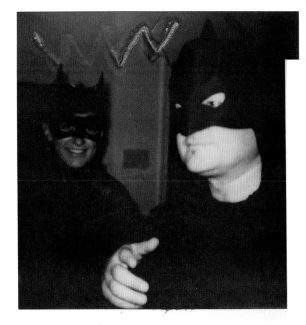

BRANDI / THEO EPSTEIN, EDDIE
KAELYN MEEK ADAMS THE FIRST, CHRIS ADAMS / STEFAN, JACLYN

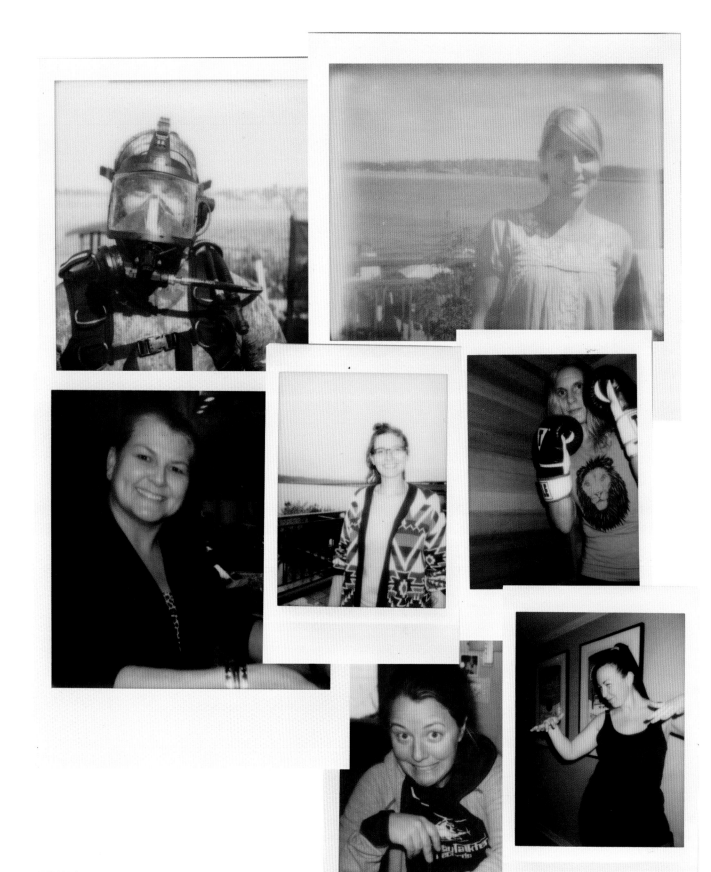

JACK WORD / ANGIE REDMAN
RENA O'BRIEN / MARY / CARLA WILCOX
ERIKA WORD / ERIKA LOCATELLI

KAELYN / CHRIS
GLENNA WILEY / JULIE ANDRES

ASHLEY ELAINE O'CONNER McCREADY / HENRY
JAXON / KAIA

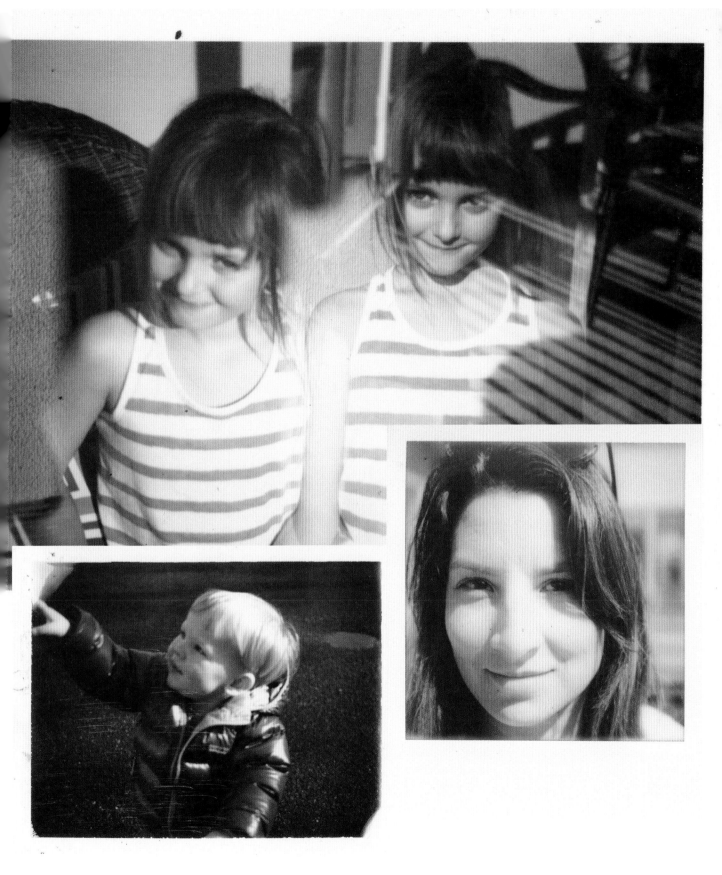

KAIA
HENRY / ALEXIS CHAVEZ

JAXON, KAIA, MIKE WELLS, KENDRA WELLS, MICHAEL WELLS, MADISON WELLS / HAZEL LESSARD
MELISA WALLACK, STEPHEN WALLACK / JAXON, KAIA

BELLA, JESSICA CURTIS / SIMONE McCREADY, RACHEL GREGORY
LIL McCREADYS / JAXON, KAIA

MARK SMITH / MY SIS SIMONE
HENRY / SHERRY, GRANDMA, ASHLEY

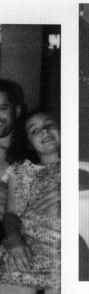

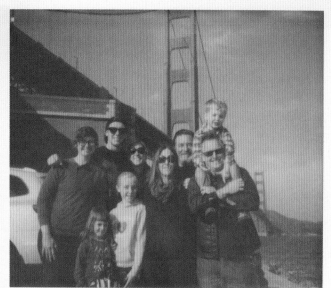

CHRIS, STEPHANIE, HELEN, CHUCK, LILY / MARY, KAIA, MICHAEL, MADISON, KENDRA, ASHLEY, MIKE, JAXON
JAXON, TOWNES CHINN / BRIAN BUCSIT

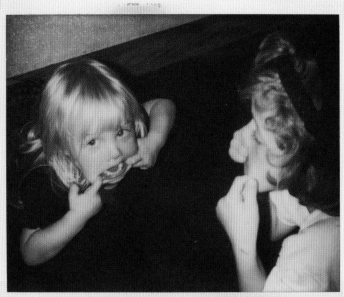
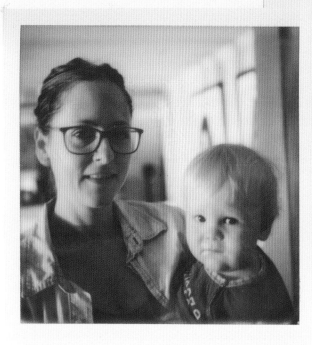

EVAN DELAY / LULU WISSMAR AND MACKENZIE MERCER
ASHLEY, HENRY / MOM

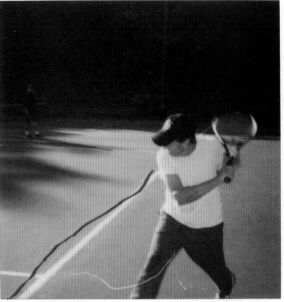

Roy Mccready
My Dad who I take
after / Hes Better at Tennis

LUCKY, LUCY / ROY McCREADY
TOM TAYLOR, MIKE CRAIG / THE NEWCOMB FAMILY

All the Kids...hopefully

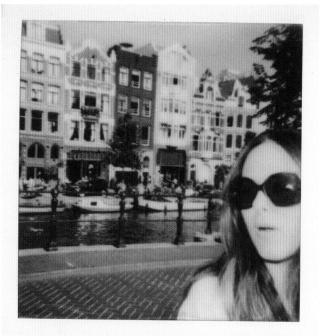

April 8th 2014

April 16 2014

THE KIDS / ASHLEY
HENRY / WILLA CHINN, KAIA

TOM & MARGIE O'CONNOR / ROY McCREADY, SANDY LORENTZEN
ANGIE REDMAN, PATRICK CHINN / TOM

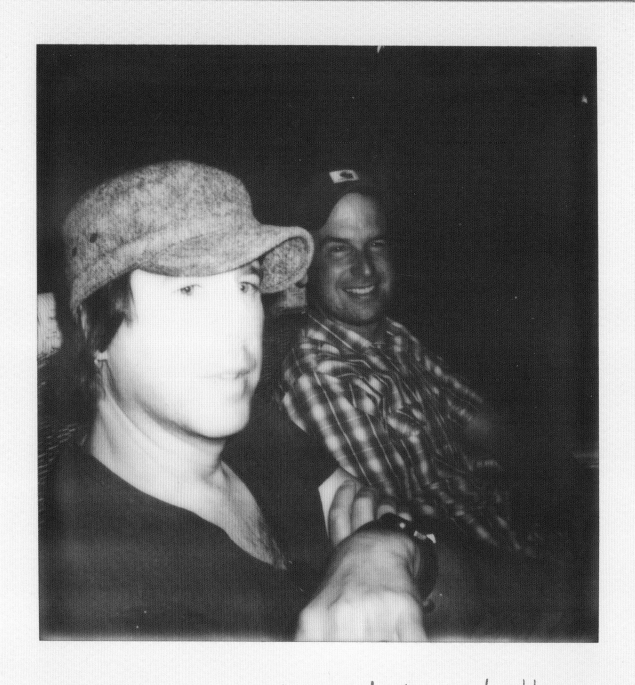

These Guys pushed me to be a better
musician / Cut our teeth in Warrior
& Shadow

CHRIS FRIEL, DANNY NEWCOMB

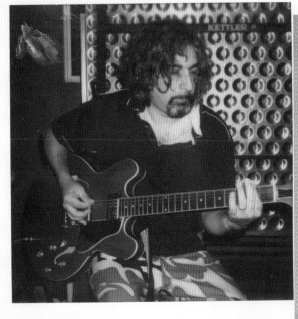

CHRIS / TIM DiJULIO

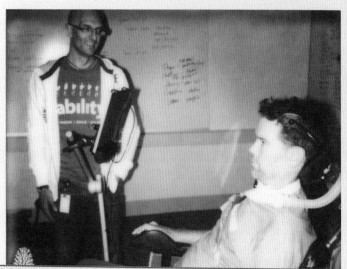

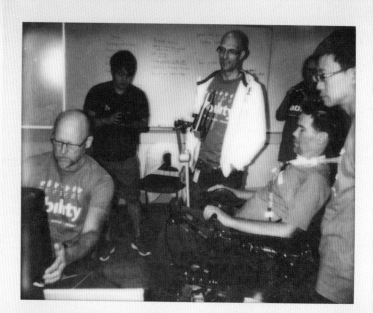

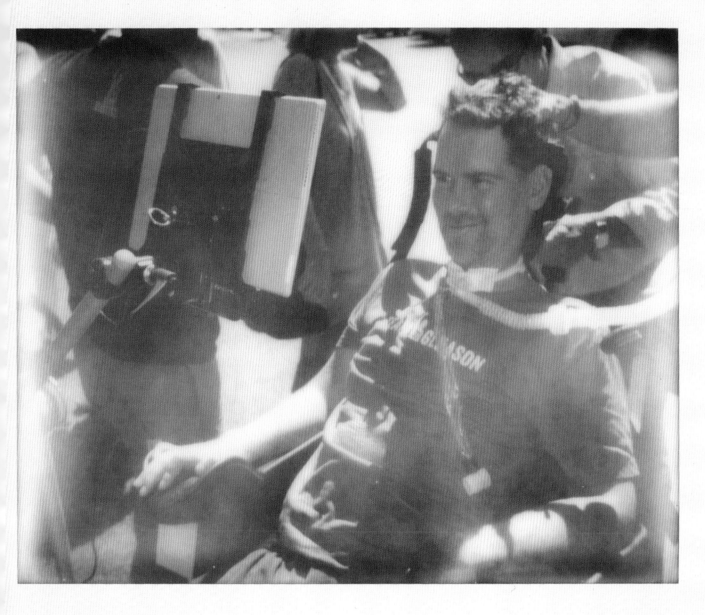

The Most impressive, Forward thinking, Caring, Pro-Active Person Ive ever Met.

< MICHEL VARISCO GLEASON STEVE GLEASON

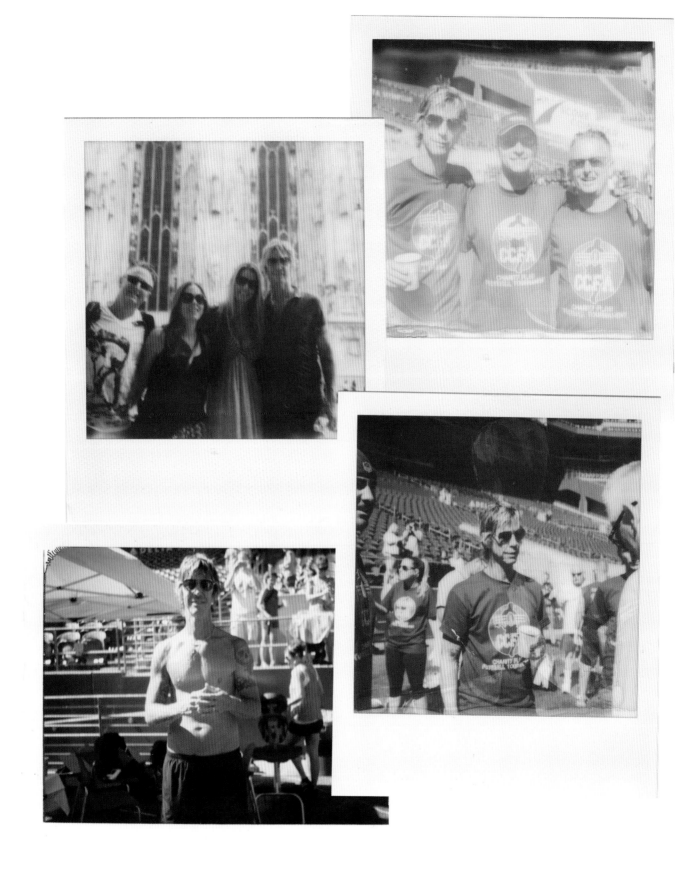

DUFF, BRAD ADAM

SUSAN HOLMES McKAGAN, DUFF

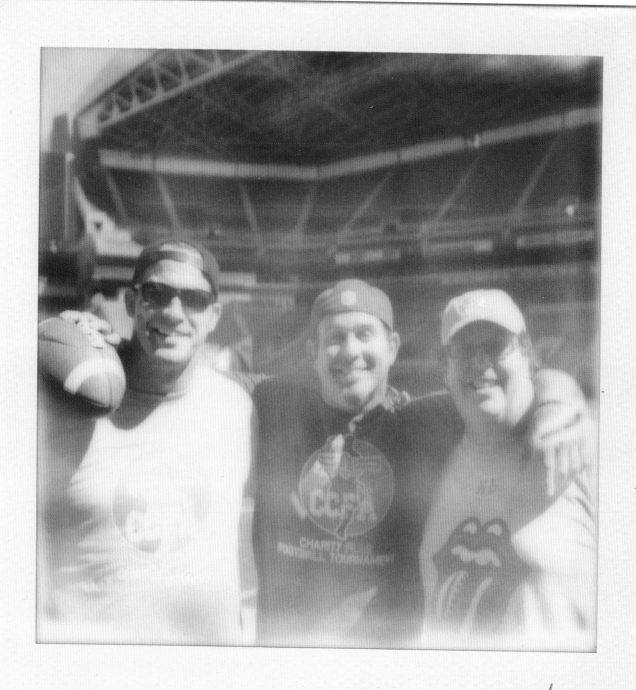

CCFA Flag Football Tournament
Chris Adams Put together

CRAIG TERRILL, CRAIG GASS, MIKE GASTINEAU

DANNY / KAREN LORIA
JON TESTER / CHRIS, DICK FRIEL

MIKE DE LA CRUZ, MIKE WELLS
IRISH RAY, MIKE WELLS
MIKE WELLS, MIKE DE LA CRUZ

Mike Wells... Dear Friend, Savior of Some,
Waterman, Punk Rocker, Fixer of
lives & Detectorist! Paradise Cove Malibu

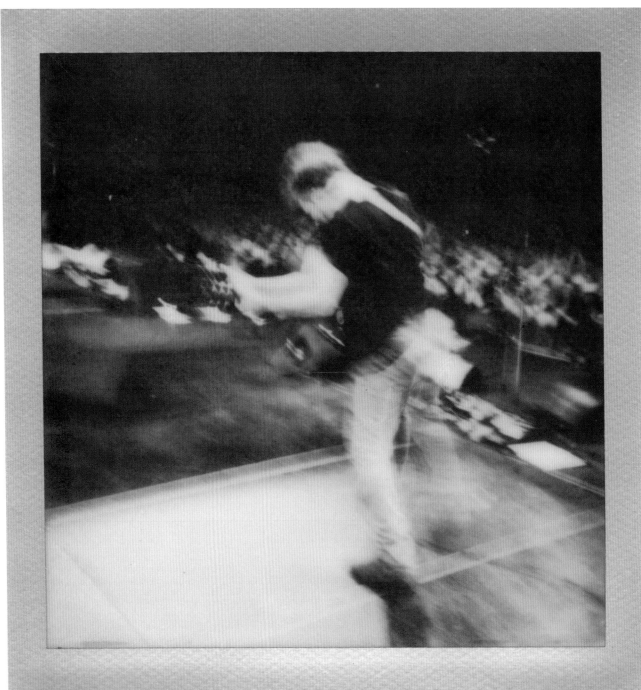

Ed Some Stage Somewhere in The World

Brendon O'brien in Eilat Isreal.

Budokan / Japan Crowd

Petster!!

Recording with Baritone Guitar
w/ Mad Season

One of the Greatest Musical Days in my life.

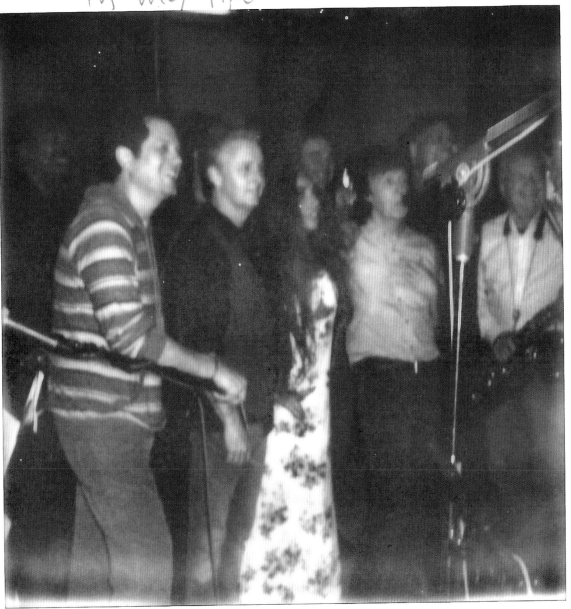

recording One of Pauls Songs

MICHAEL GIACCHINO, LADY GAGA, PAUL McCARTNEY

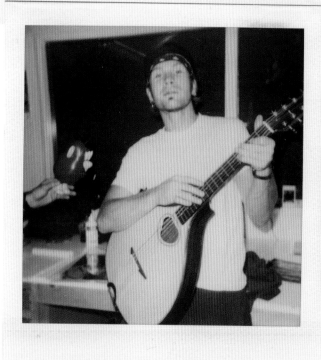

BAKER / HOPE SANDOVAL
JEFF AMENT / KIRK HAMMETT

TOMMY NIEMEYER, LAYNE STALEY

TOM PETTY / LAYNE STALEY
JELLO BIAFRA / AL JOURGENSEN

NEIL

DANNY / BENMONT TENCH
ELLIOT ROBERTS, STONE

MATT

Paradise Cove
where the Rockford
Files were Filmed

LULU, KEITH WISSMAR

MELISA
STEVE, STONE

KRISHA AUGEROT

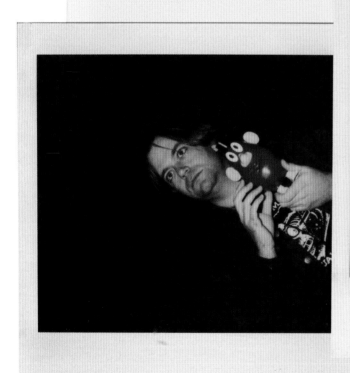
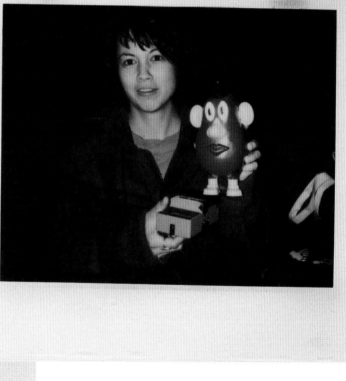

MARK, KARRIE KEYES / GEORGE WEBB
KURT / LULU

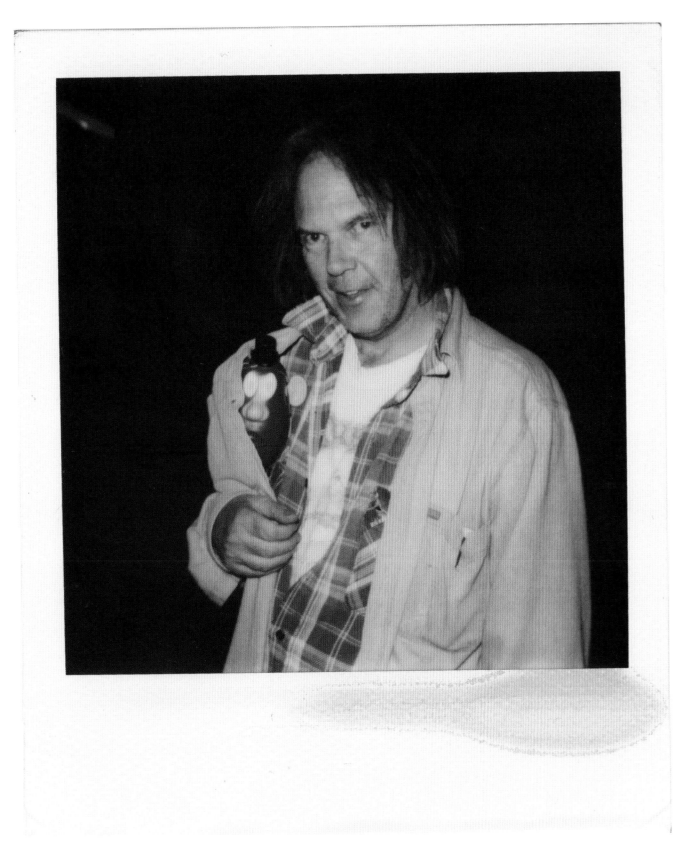

NEIL

MIKE MUSBURGER / NICKY BEAT
KEVIN SHUSS

Malibu C A.

Krist

BAKER / CAT
BILLY TALBOT, RALPH MOLINA / COURTNEY CLARKE

EDDIE

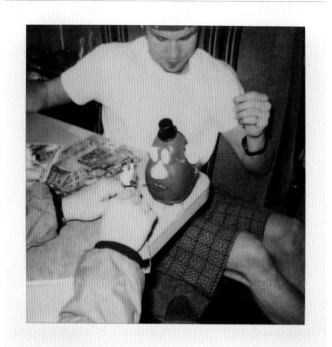

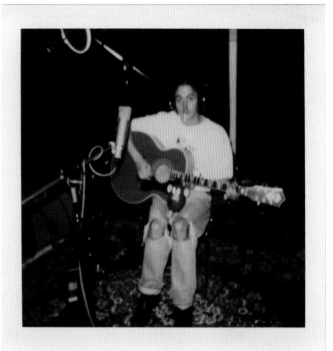

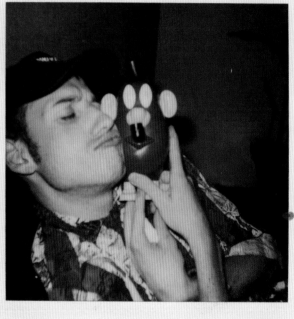

JEFF
NICKY / STONE

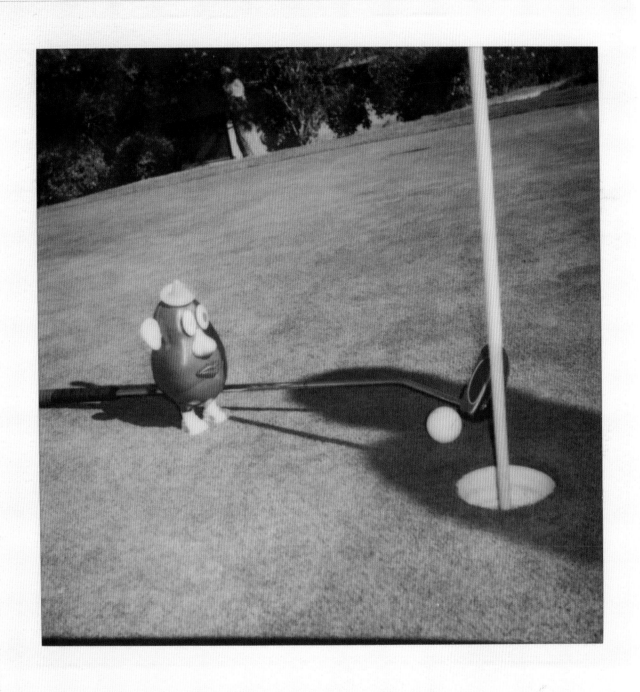

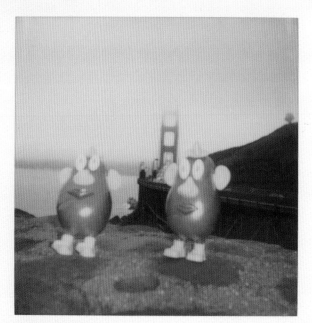

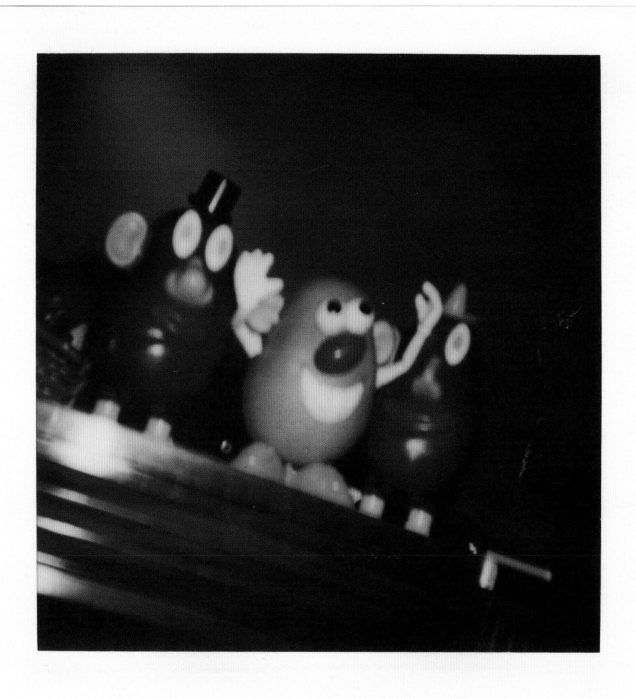

< ROBYN HOLLOMAN

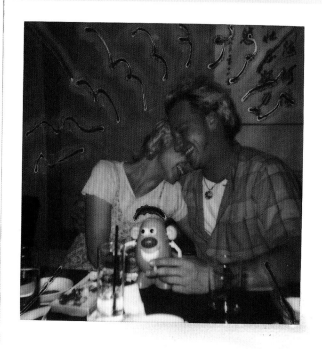

CARY KEMP / KEITH
STEFFA JOHNSON, ERIC JOHNSON / KEVIN

LULU

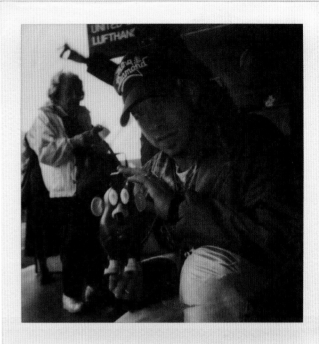

BRENDAN, JEFF / ERIC
MARA THOMAS / LANCE MERCER

COURTNEY

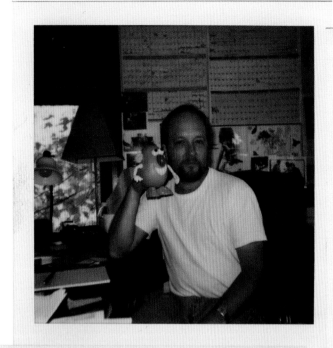
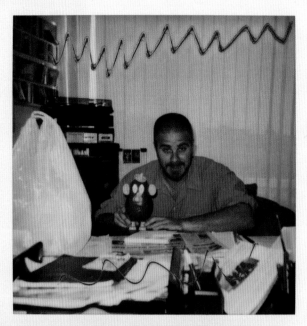

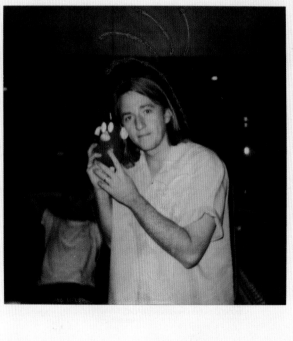

KELLY CURTIS / BERKO PEARCE
MR. POTATO HEAD / BRENDAN

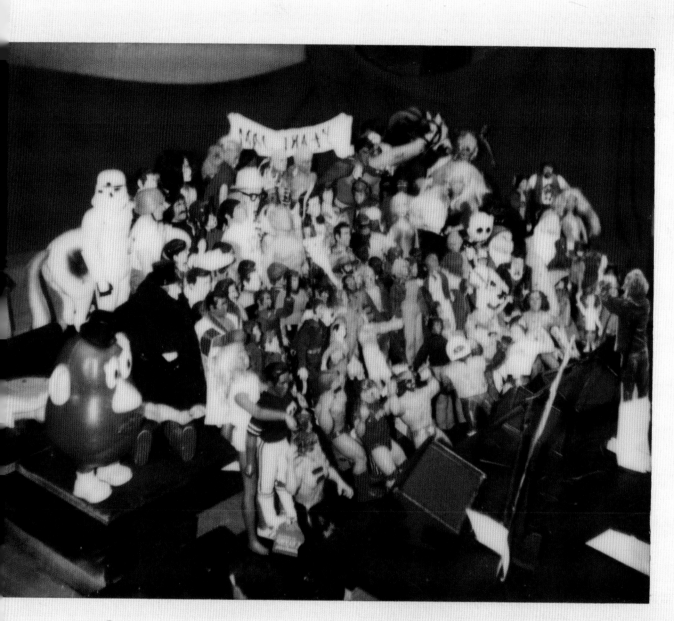

Pearl Jam Xmas Single
w/ Potatohead

GEORGE / PETE
JOHN BURTON / LULU

Damon Stewart
"The Guru" KISW DJ

DAMON STEWART

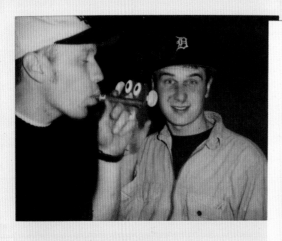

KIRK
LANCE, DANNY / JEFF, KEITH
DAN

ERIC

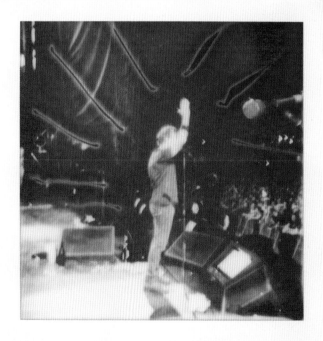
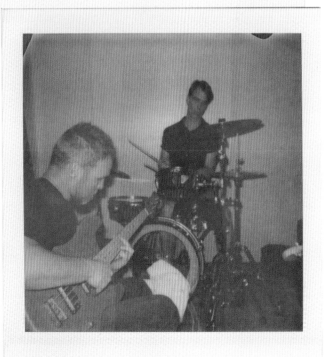

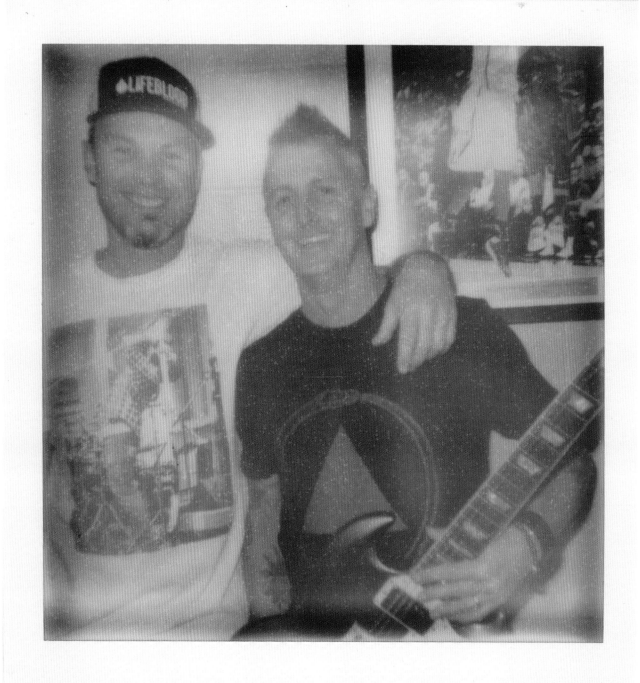

Photo by Danny Clinch

JACK IRONS

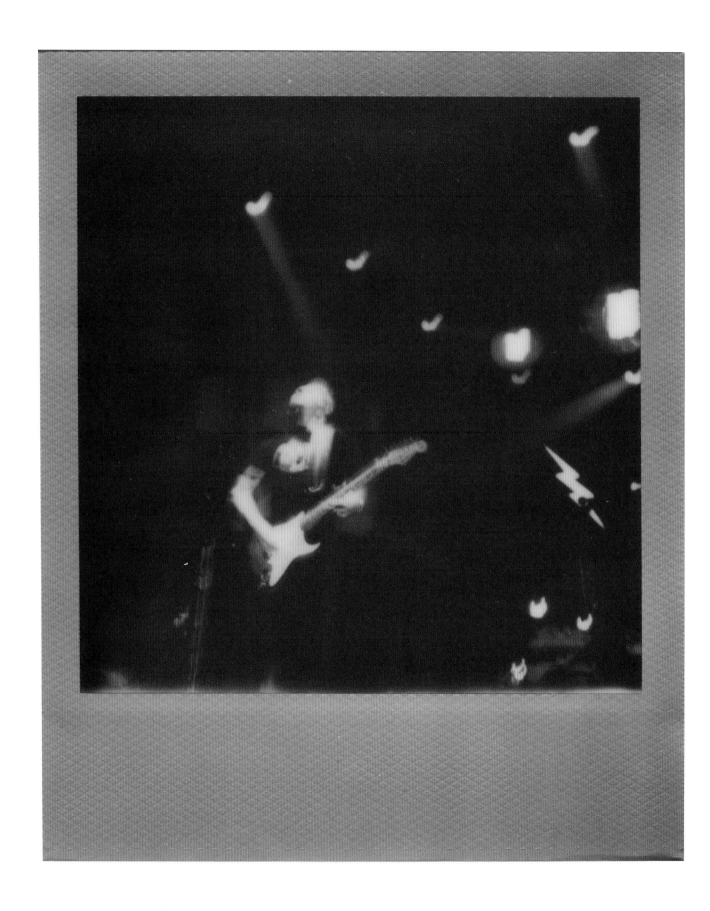

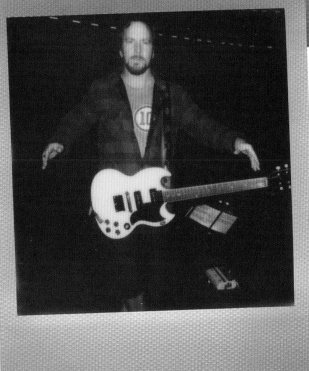

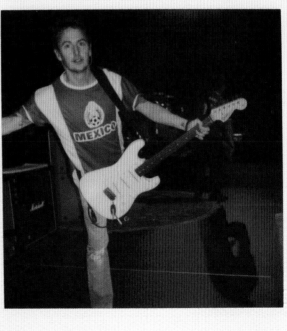

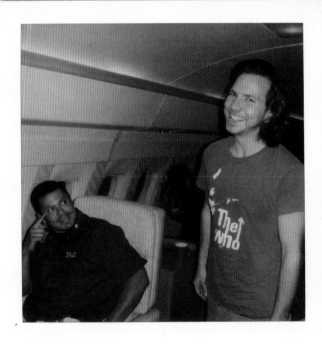

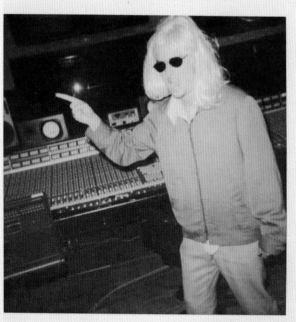

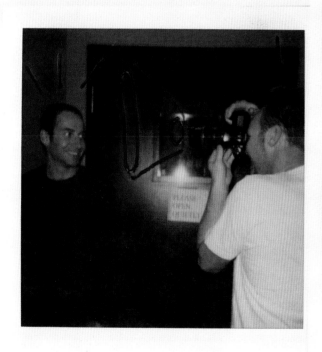

Me breaking the first Guitar Jeff & Stone bought me. 1962 reissue Black Stratocaster at Mad Season Moore Show

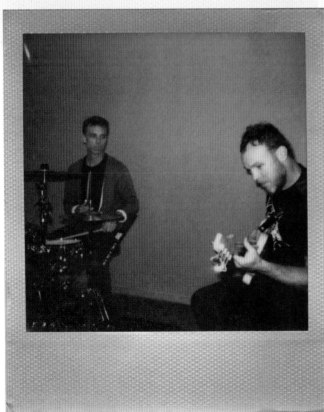

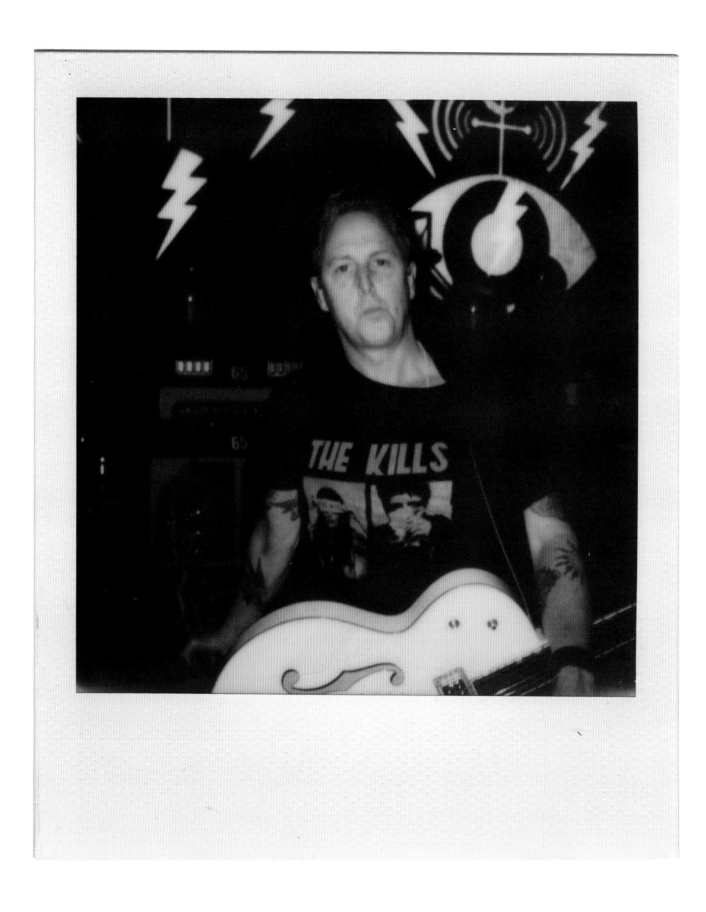

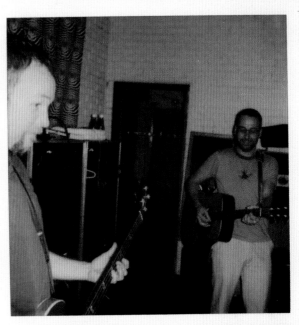

PETE BEATTLE

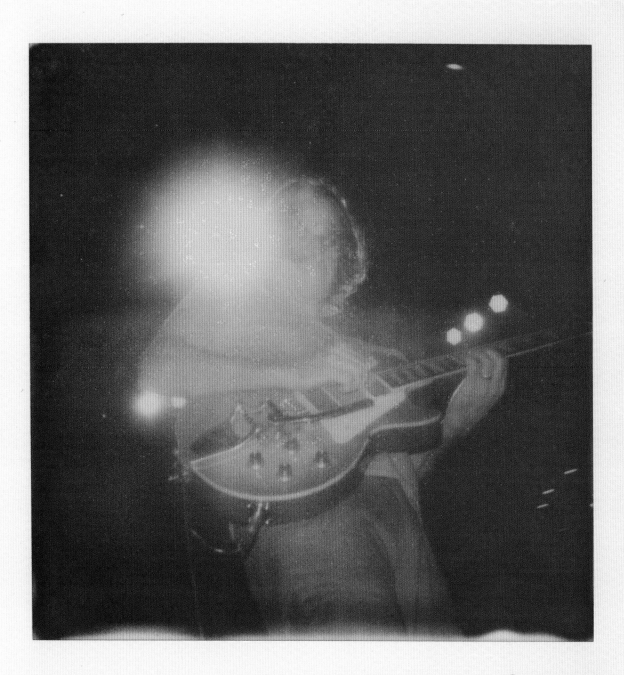

alot of times I will hand my Polaroid
to Danny Clinch & suprise him

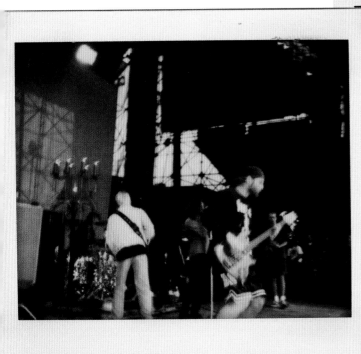

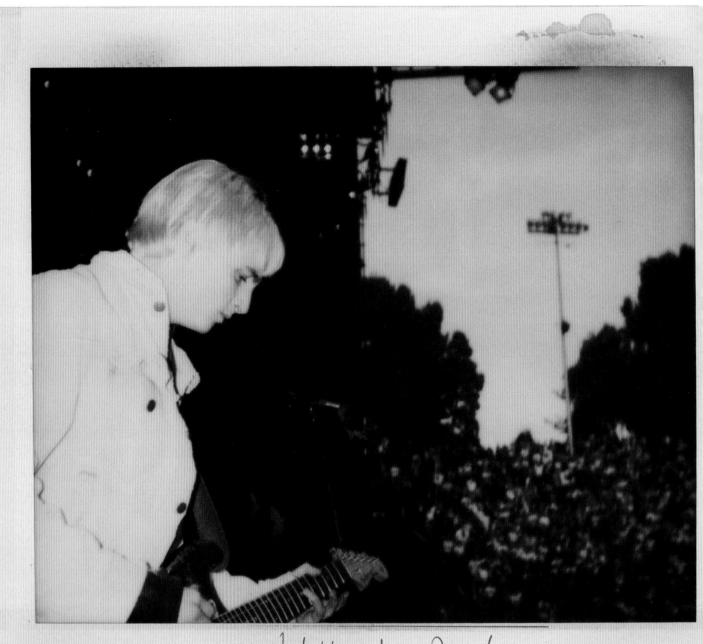

Wuhlheide Berlin.
Love to play here

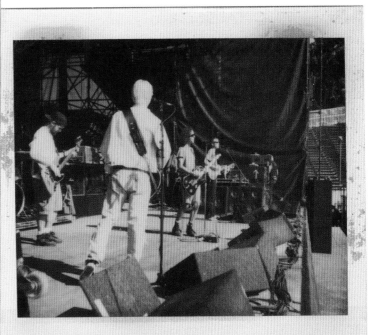

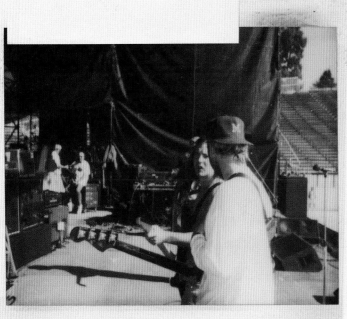

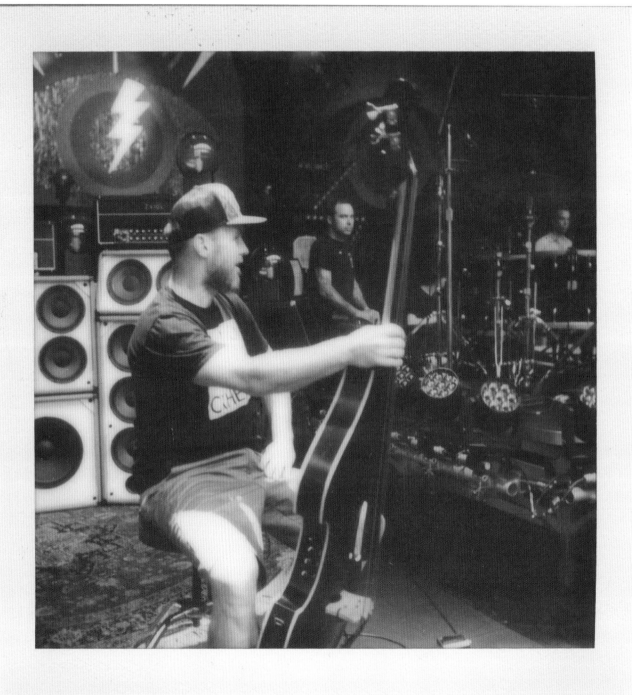

Boom Giving Me tha Shaka

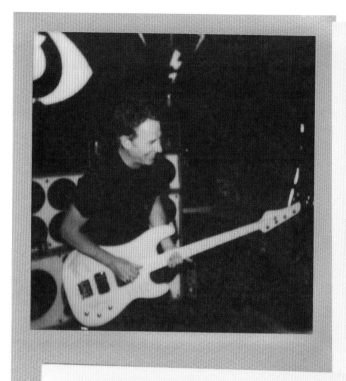

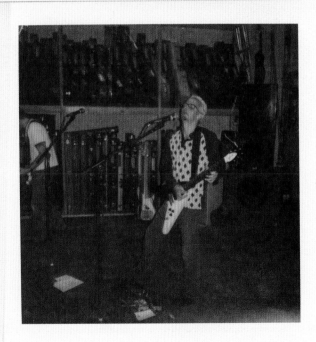

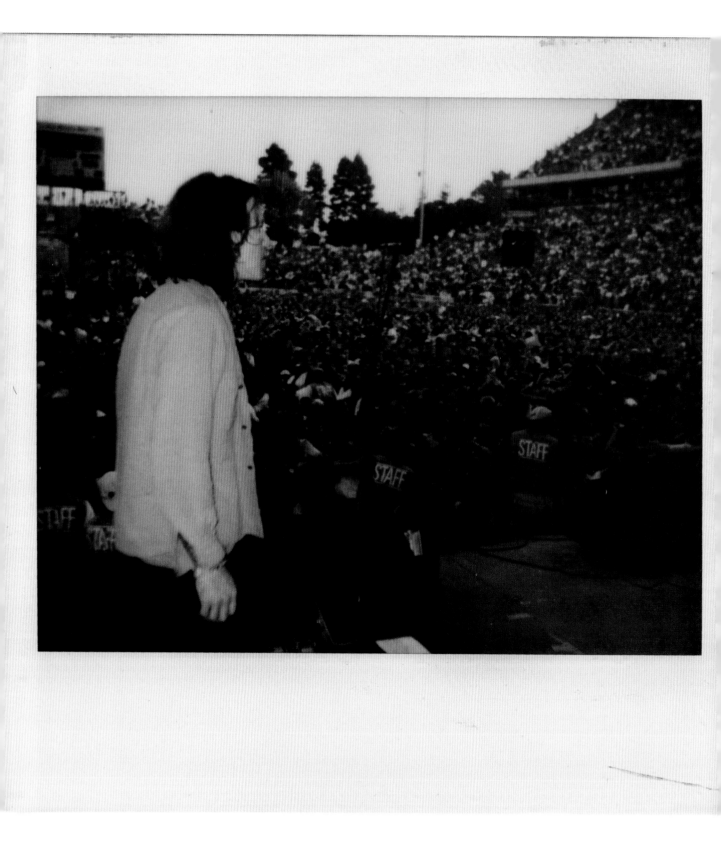

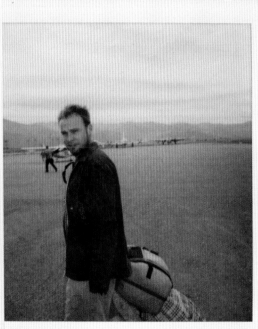

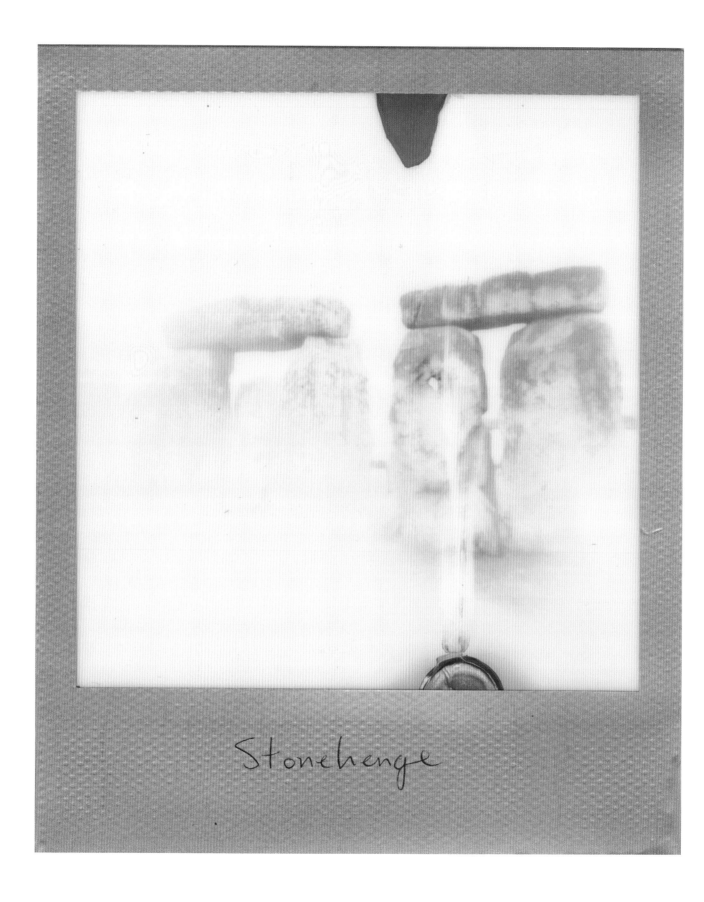

Stonehenge

England Prince Albert Statve Hyde Park!

Amsterdam

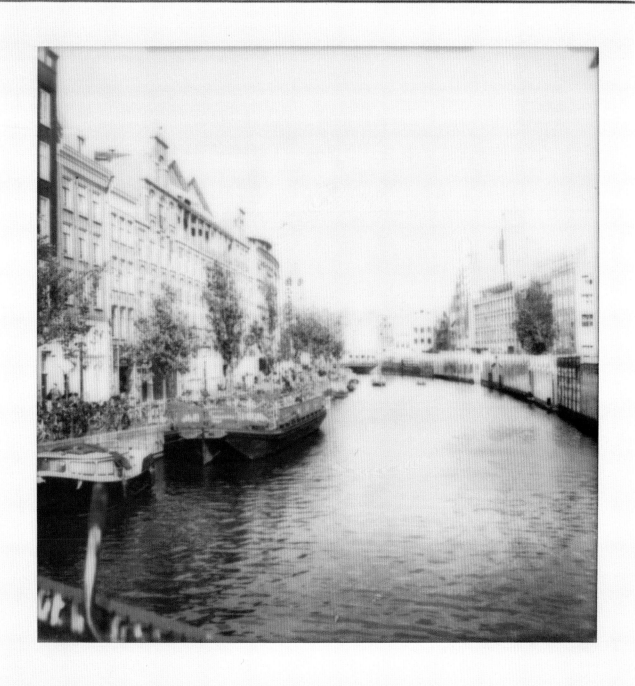

Amsterdam Canal

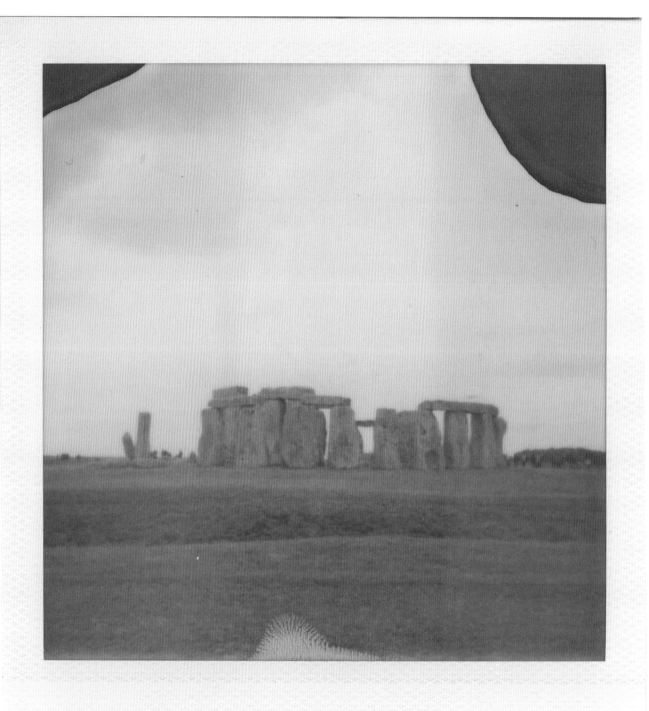

Stonehenge with old film

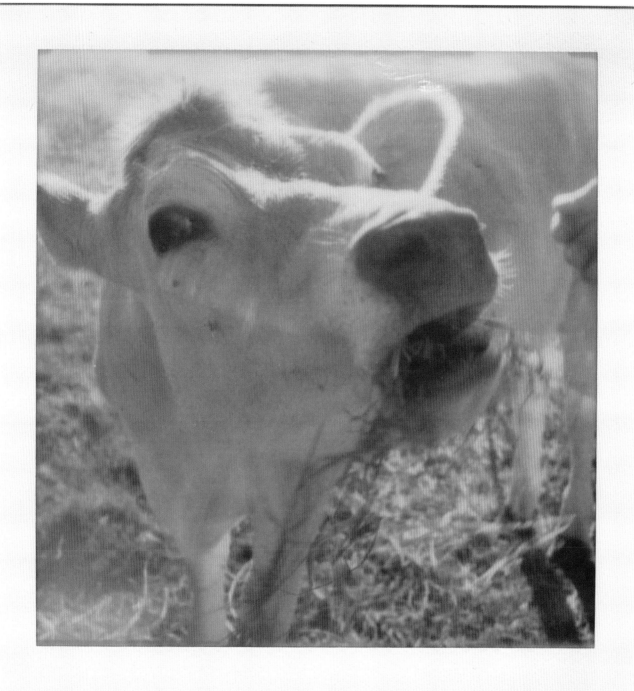

Cow at Dannys Farm

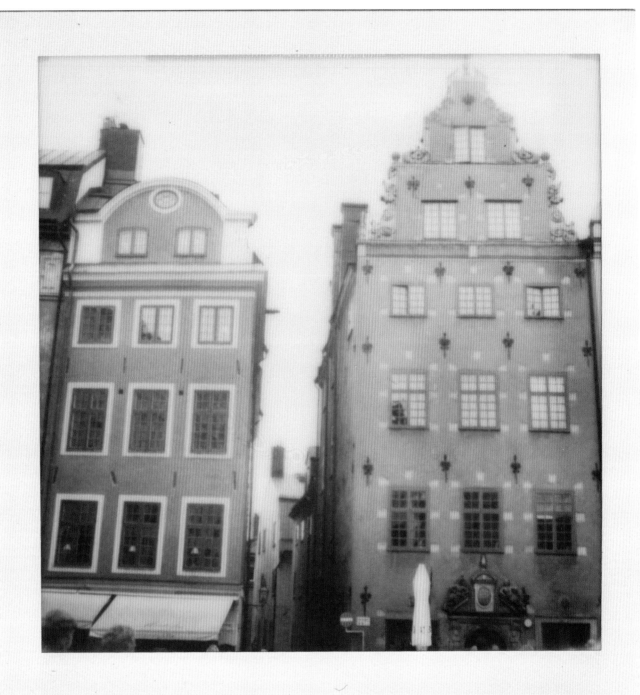

Brussels!

Notting Hill England
Blue Filter Impossible Film

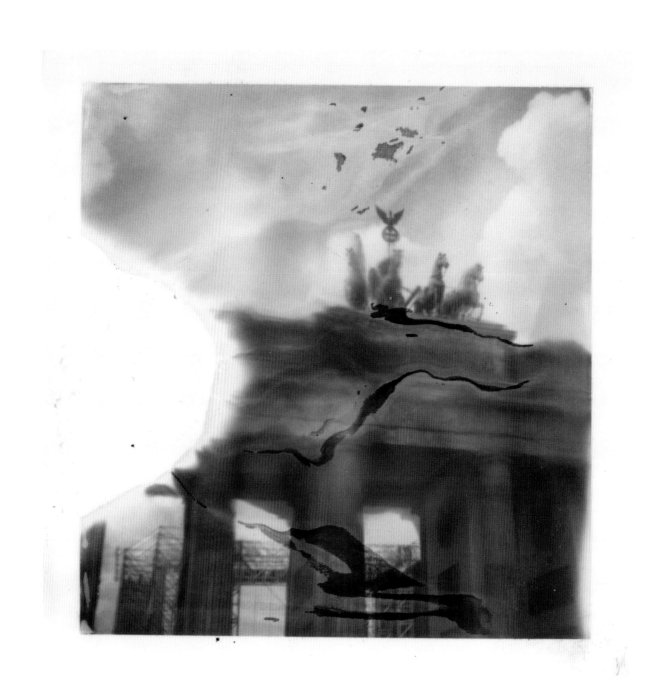

Brandenburg Gates
with Expired Film

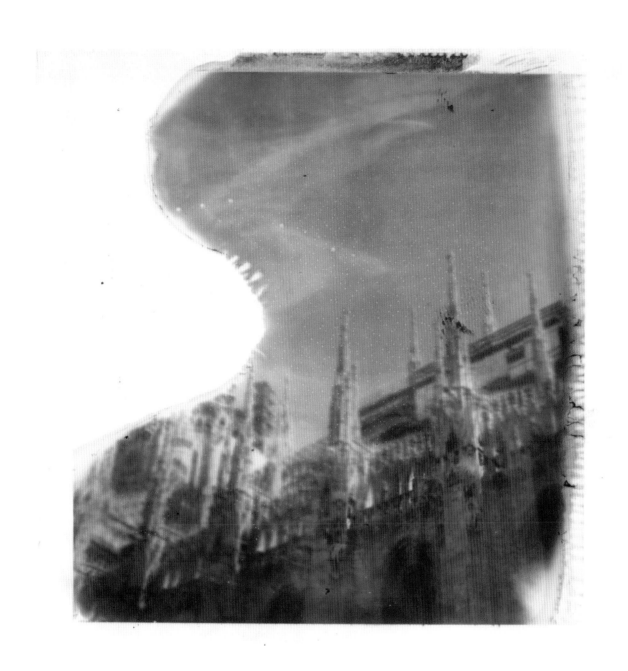

The Duomo Milan

Sweden

Duomo Milano

700 year old Bridge

Salisbury England

Orange County Fair

Hunting for beach

Fabulous Sunset Strip
Los Angeles CA.

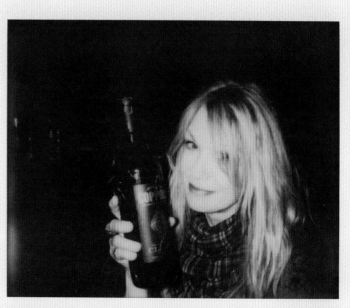

HILLARY CLINTON, KAIA / NANCY
ASHLEY, WILL FERRELL / BILLY IDOL

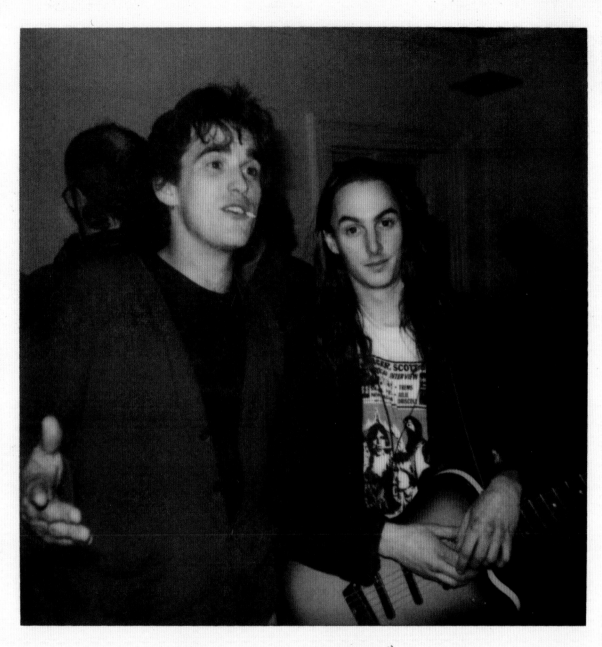

Early 90's Singles era
I miss that Stones T-shirt

MATT DILLON

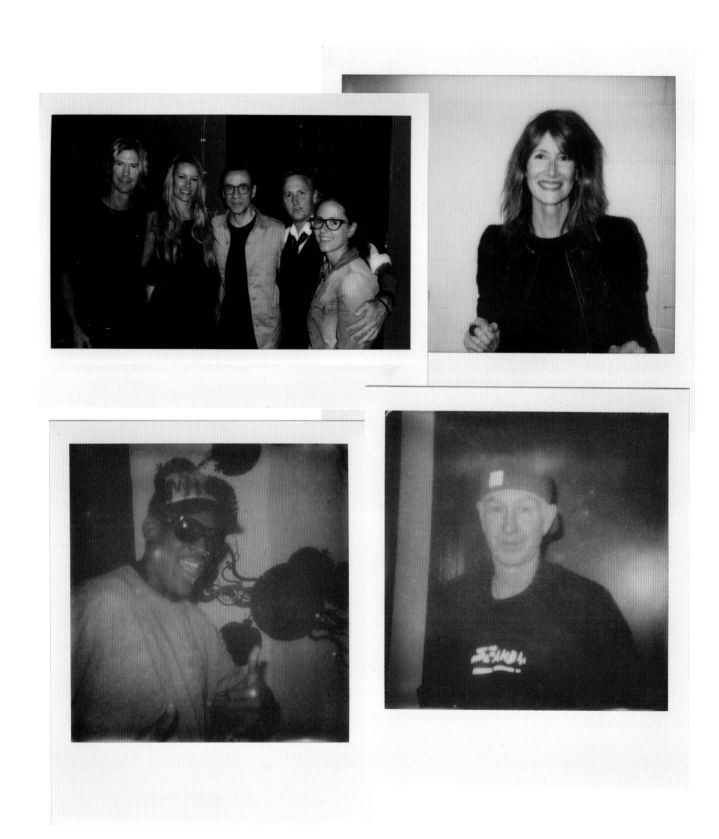

DUFF, SUSAN, FRED ARMISEN, ASHLEY / LAURA DERN
DENNIS RODMAN / JOHN McENROE

LESLIE MANN, GENE

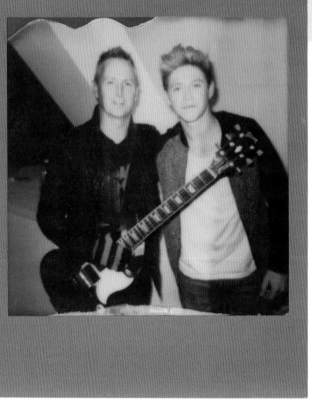

MIRA SORVINO / LAURA DERN
PATRICK WARBURTON / NIALL HORAN

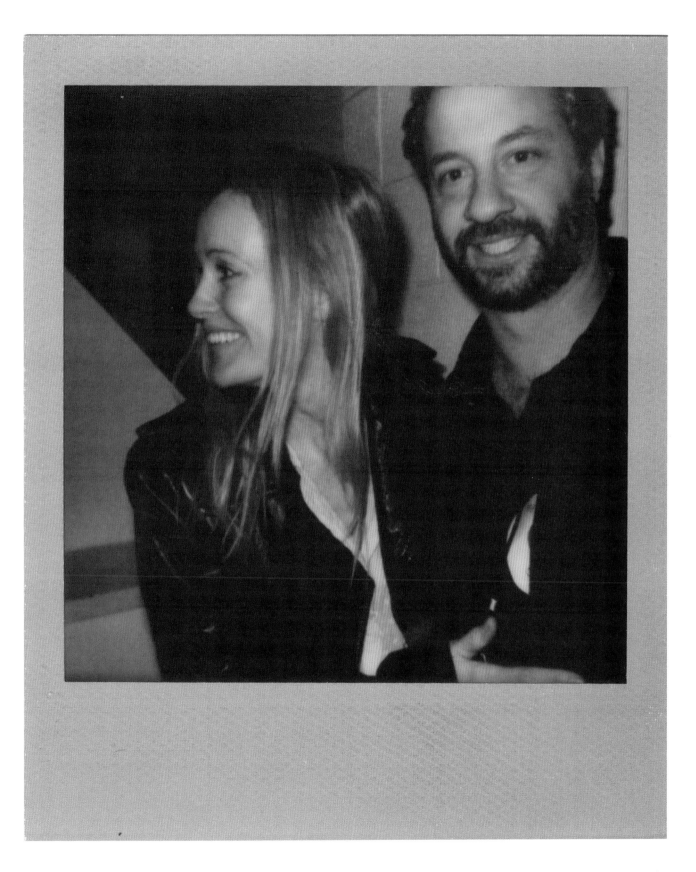

LESLIE MANN, JUDD APATOW

TIM ROBBINS

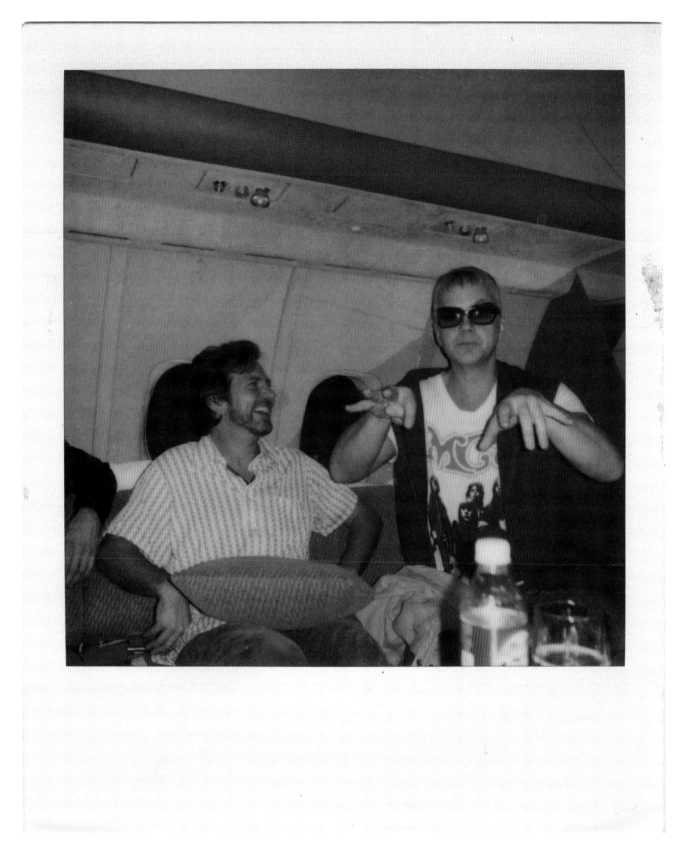

EDDIE, TIM

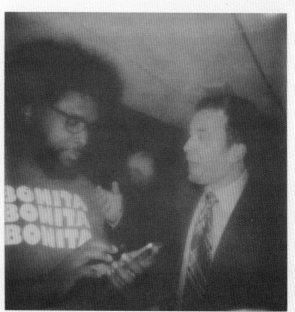

QUESTLOVE / QUESTLOVE, JIMMY FALLON
DANNY / JAVIER BARDEM

JIMMY

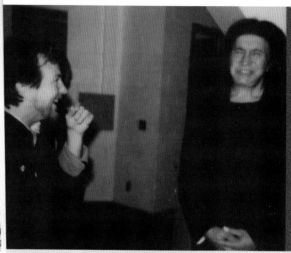
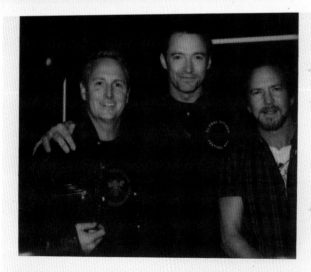

He came from the land
of Ice & Snow to Bring

< JAMI GOLDMAN MARSEILLES / LADY GAGA
< THUNDERPUSSY / EDDIE, GENE
< HUGH JACKMAN / ROBERT PLANT

MATTHEW LILLARD

BRENT BARRY

DAVE HANSEN, RICHIE SEXSON, RAÚL IBAÑEZ / CRAIG GASS
FENWAY / MARK RICHARDS

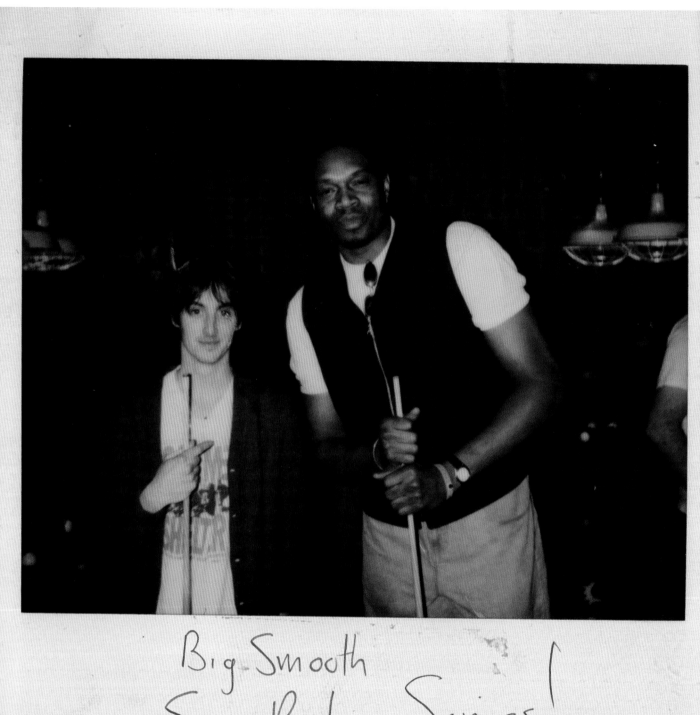

Big Smooth
Sam Perkins Sonics!

SAM PERKINS

Raising the 12^th Man Flag on Space Needle Go Hawks!

RANDY JOHNSON

VENUS WILLIAMS / MICK FANNING
MARK TRUMBO / RANDY

175

JEFF, JACK / JEFF, STING
STING / RICK, DANNY

KATE HUDSON
DUSTIN HOFFMAN / RICK
KATE

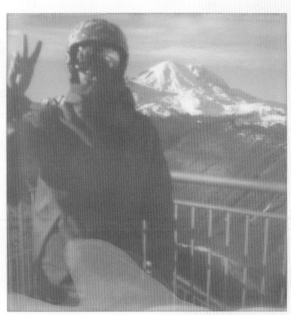

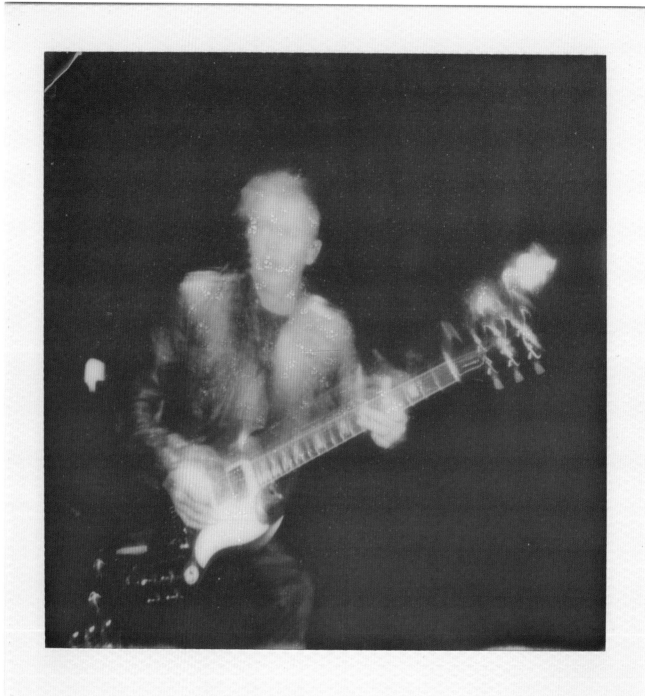

Photos by Danny Clinch

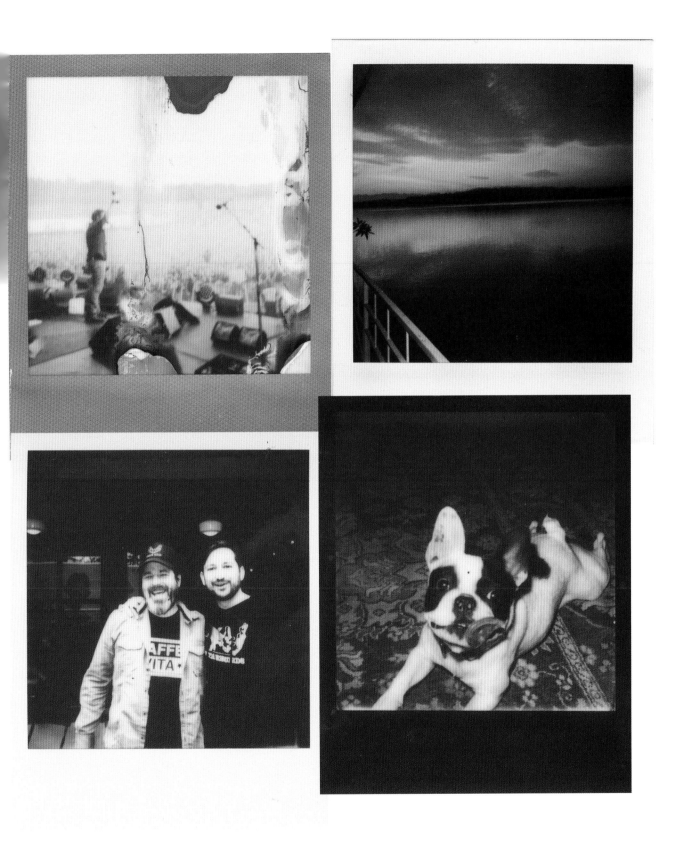

EDDIE
RICK, SKYLER LOCATELLI / REY

PETE, ELAINE SUMMERS / MIKE, MIKE
MIKE, MIKE / MARK

MIKE

Part of Our Amazing Crew

ANDY WOLF / NEIL HUNDT
GEORGE / DONNIE SPADA

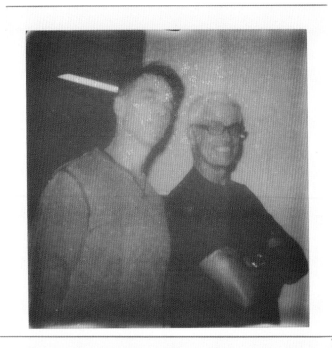

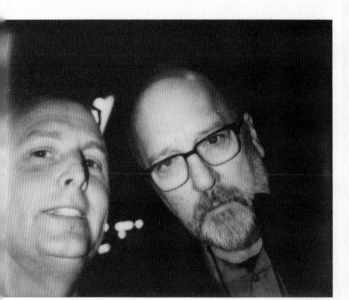

Our Manager
Guiding & Protecting
us all these years.

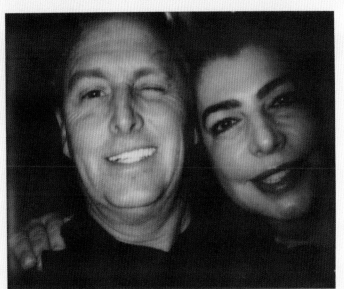

Michele is a huge reason we got to
where we are today I will always be
grateful to her vision.
& Love.

MATT, MARK / BOOM GASPAR, JOSH EVANS
KELLY / MICHELE ANTHONY

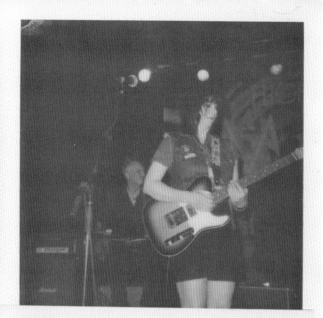

One of the best guitarists around.
Super great passion & fire. Also
Hey!! He can crack me up in a
second. Plays in Flight to Mars & Stereo Embers

< BRAD SINSEL / KATHY MOORE
< MIKE, BARRETT JONES / MIKE
< ANDREW McKEAG / PAUL PASSARELLI

TIM

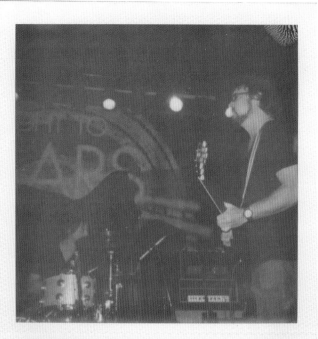

MIKE / JEFF FIELDER
KIM VIRANT, KATHY / TROY NELSON

A great Guitar player, Bass in Flight to Mars.
Super Funny. Loves Jeff Beck. One of my
Favorite things is when Gary & Kim Virant
harmonize on the third verse of Helpless.

GARY WESTLAKE

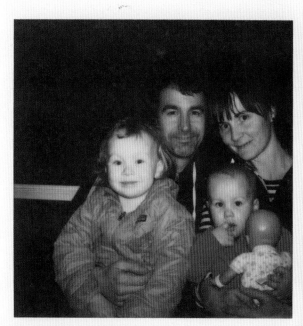
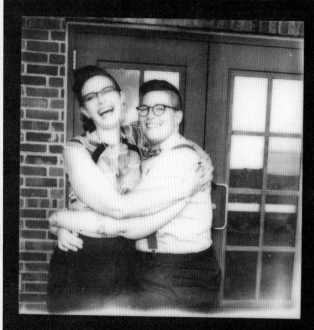
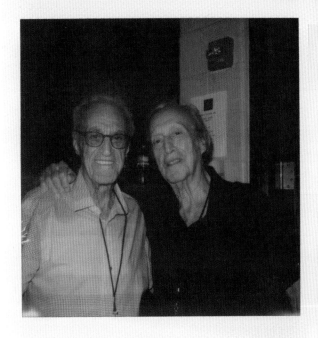
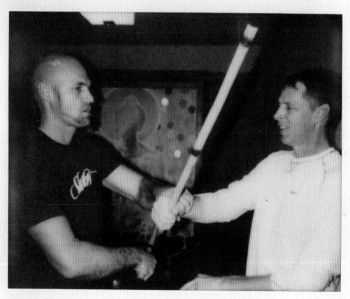

TADD SACKVILLE-WEST, KATE BAYLEY, DORTHY GREY, FINLEY / MARY, ANNA
FRANK FAVALE, JOE FAVALE / NATE SCURICH, SIFU CHRIS CLARKE

Kim Virant Jenny Marsh

SAGE REDMAN / BIG PETE
ALEX, TONYA / KIM, JENNY MARSH

Ed addresses the crowd
I like the light in this
Picture

What Can I Say.....

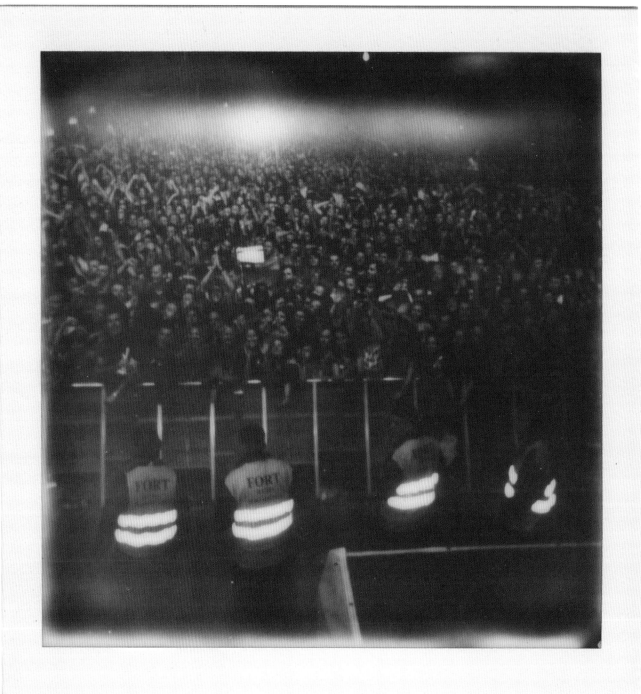

Crowds!

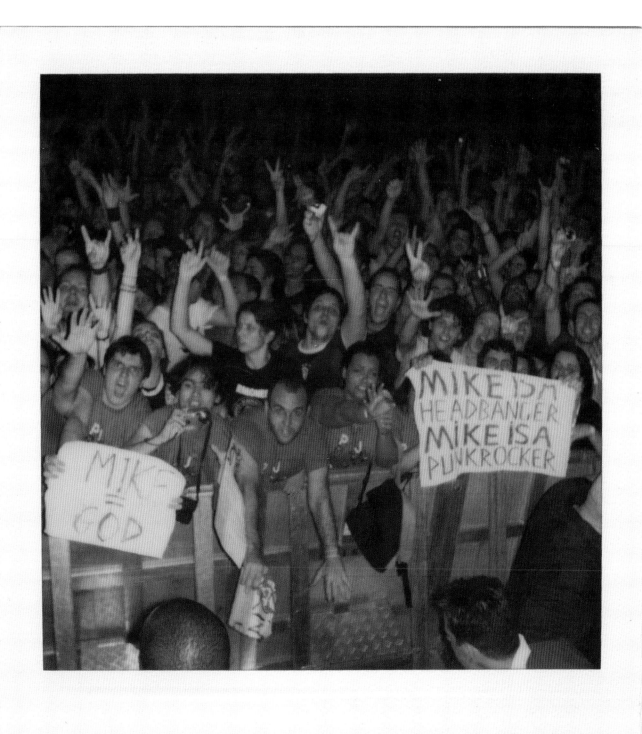

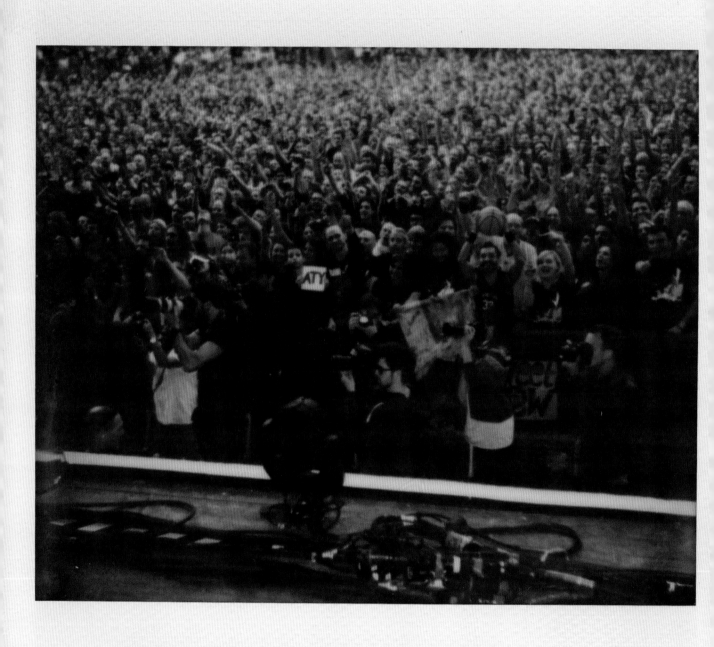

They make it Possible

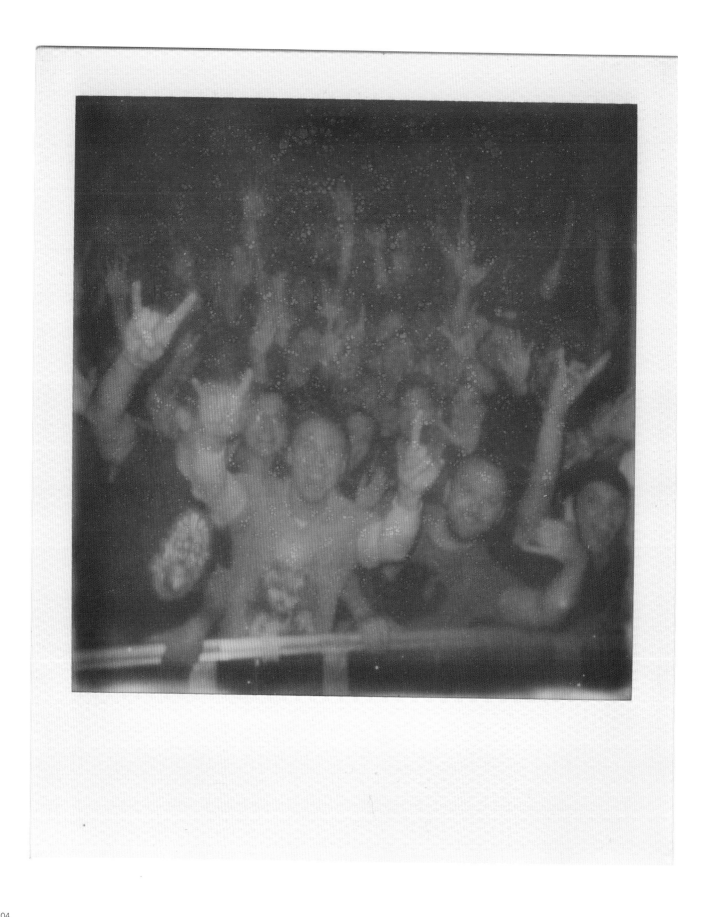

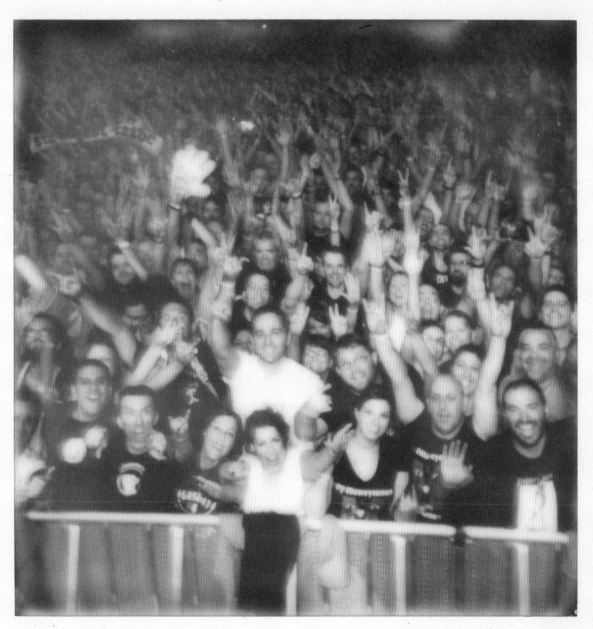

And When I search the faceless crowd.
A swirling mass of greys & Black and White.
They don't look real to me in Fact they look
so strange....

Salt of the Earth
Rolling Stones

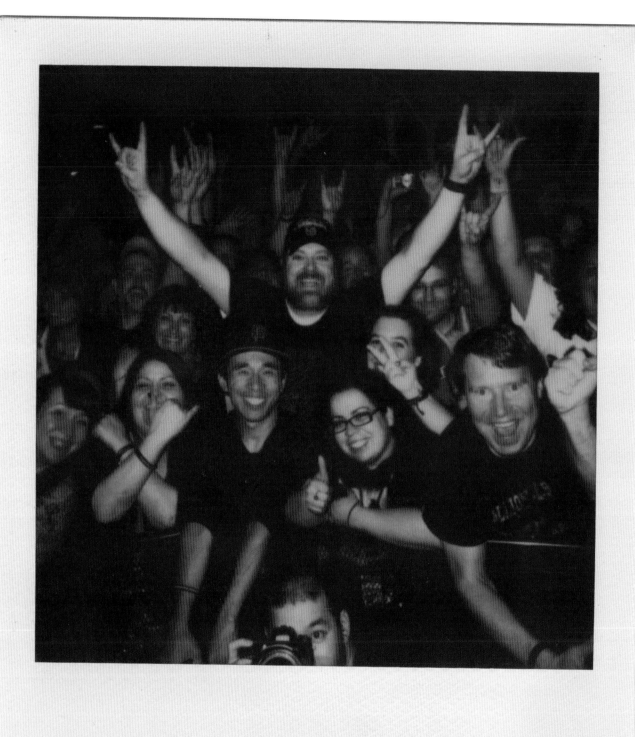

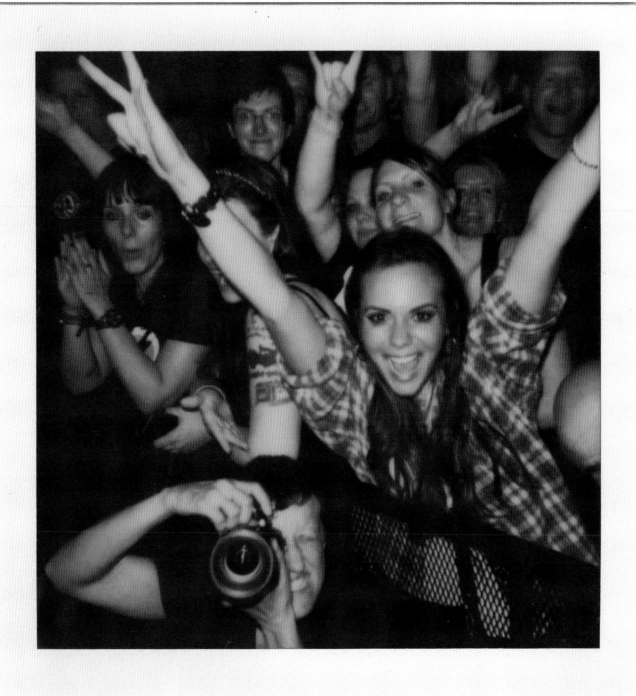

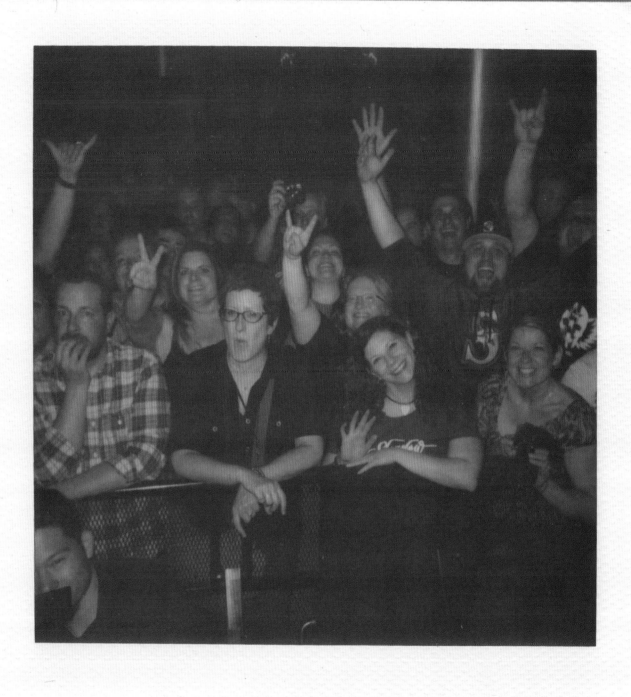

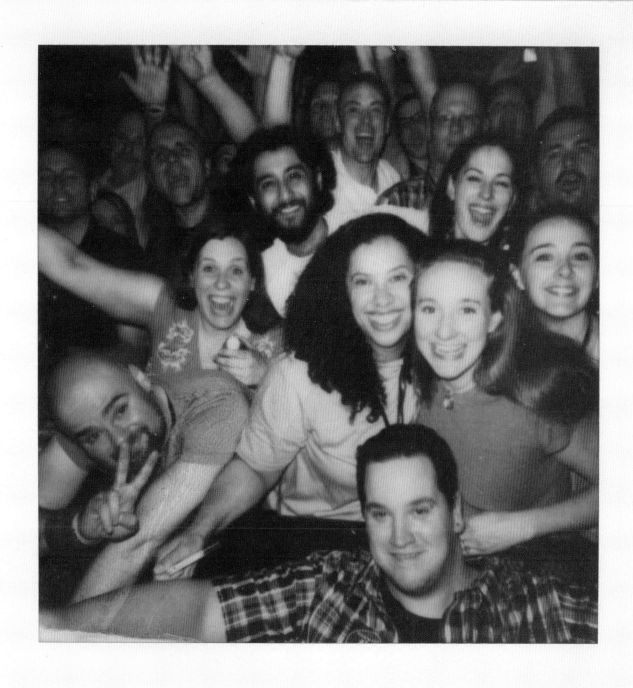

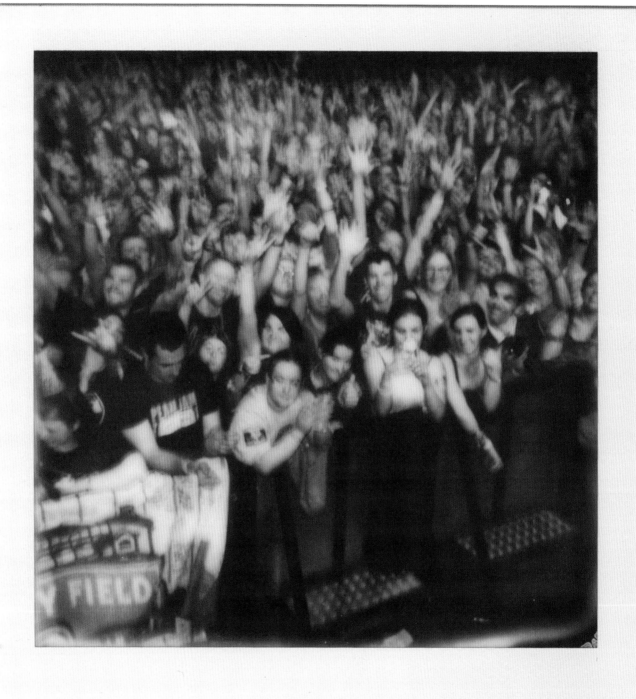

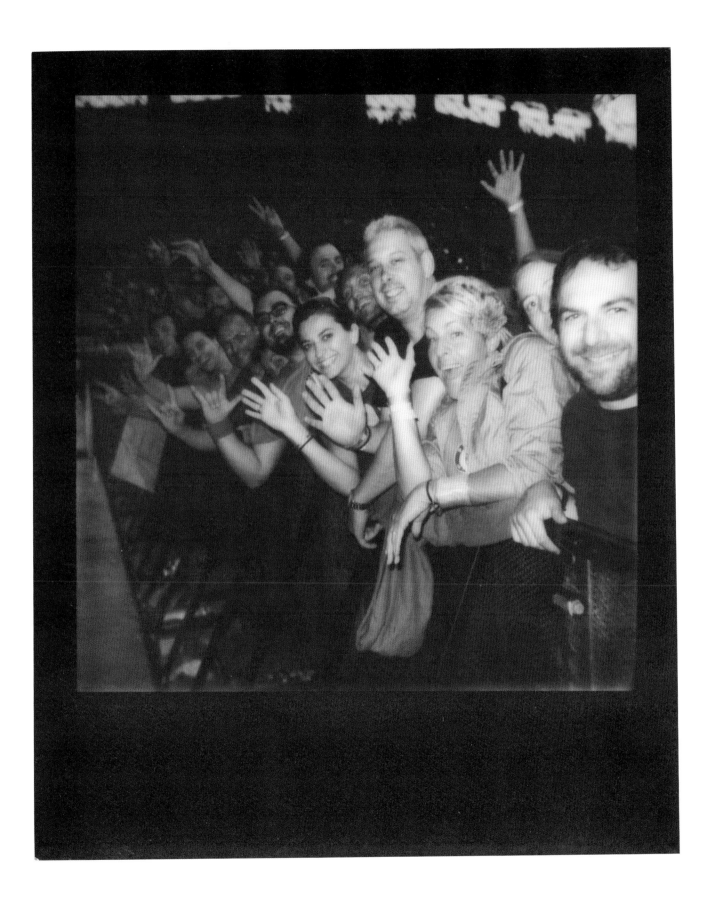

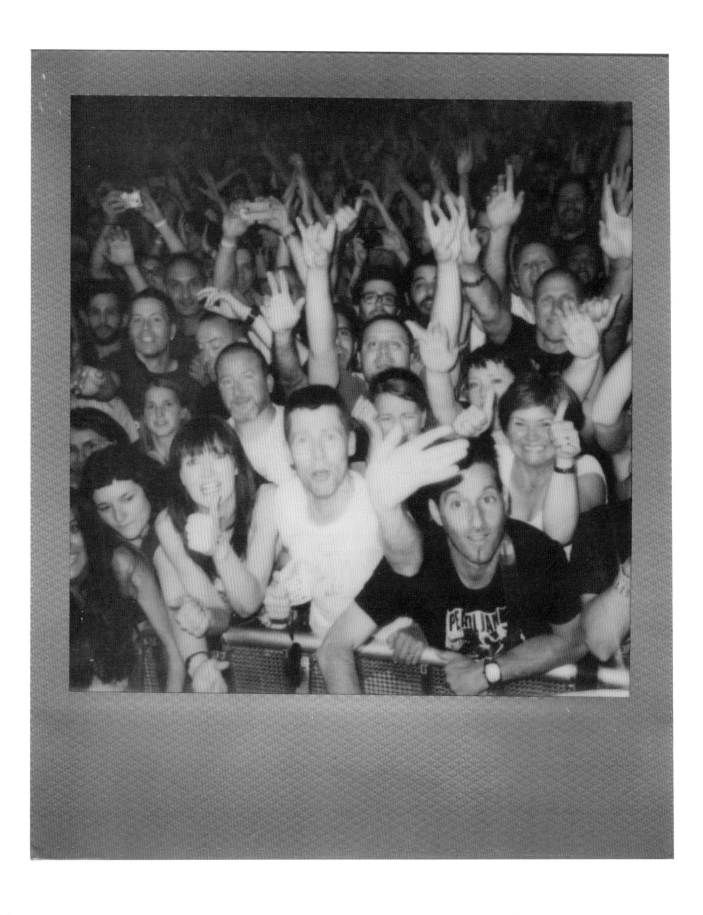

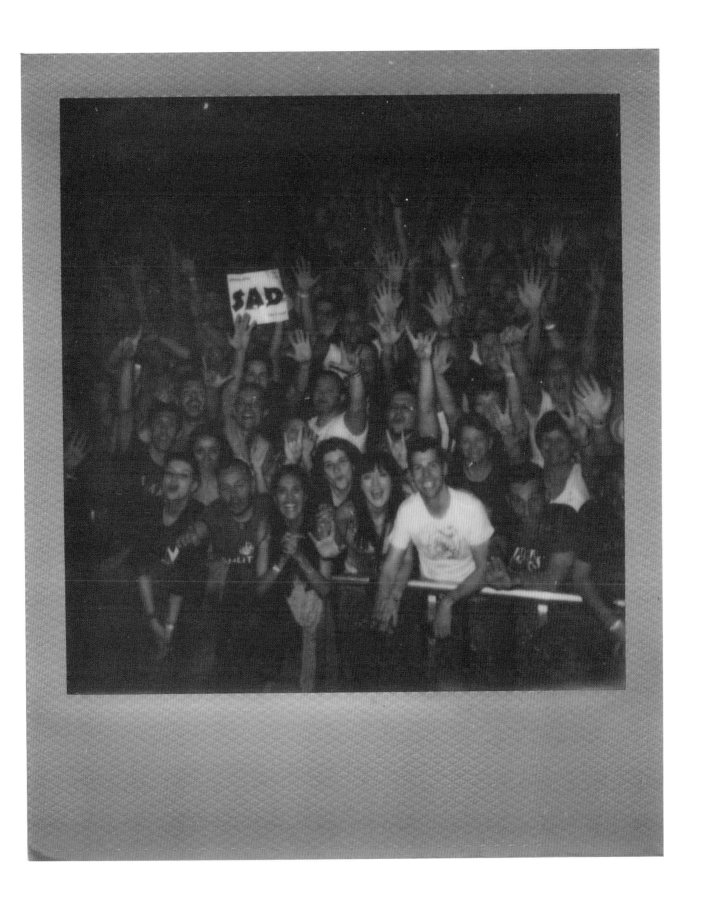

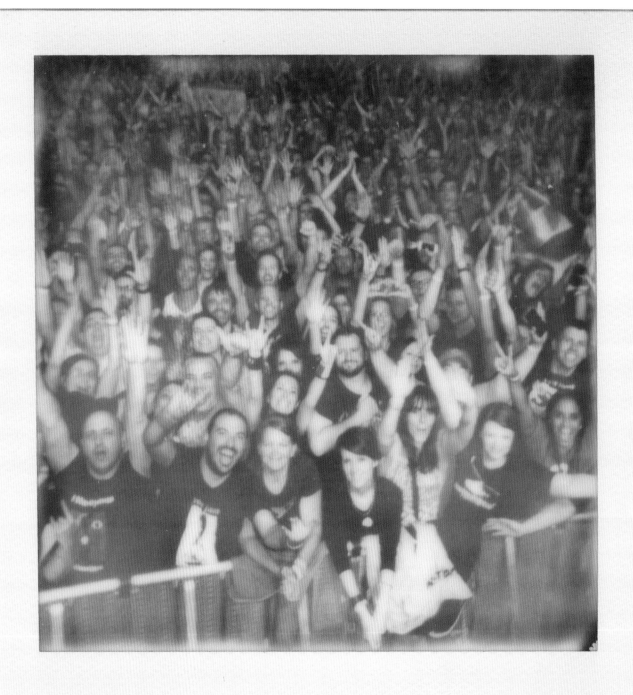

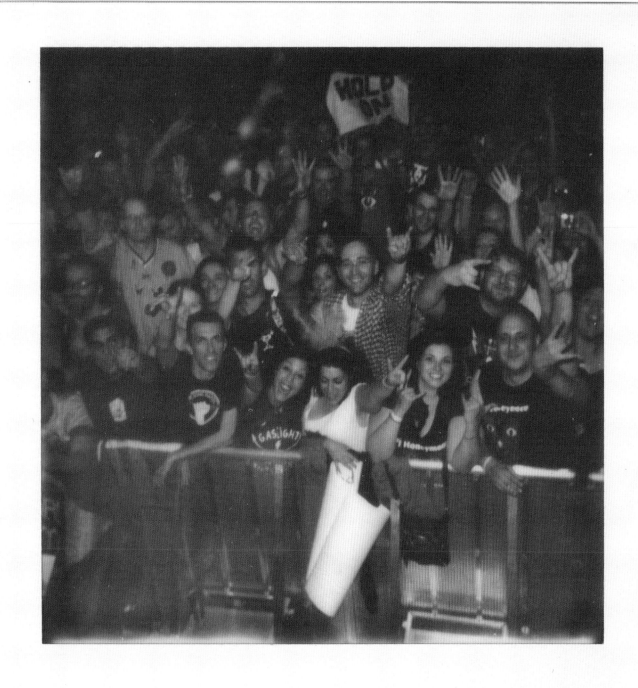

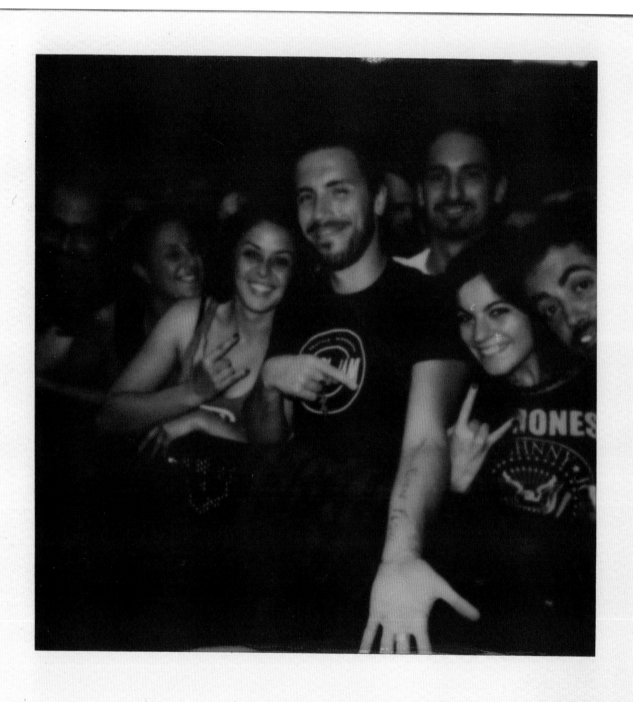

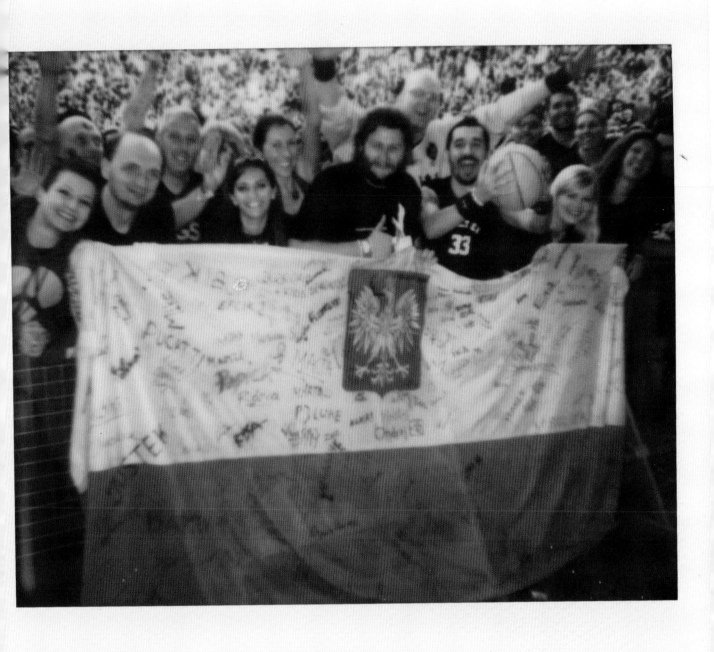

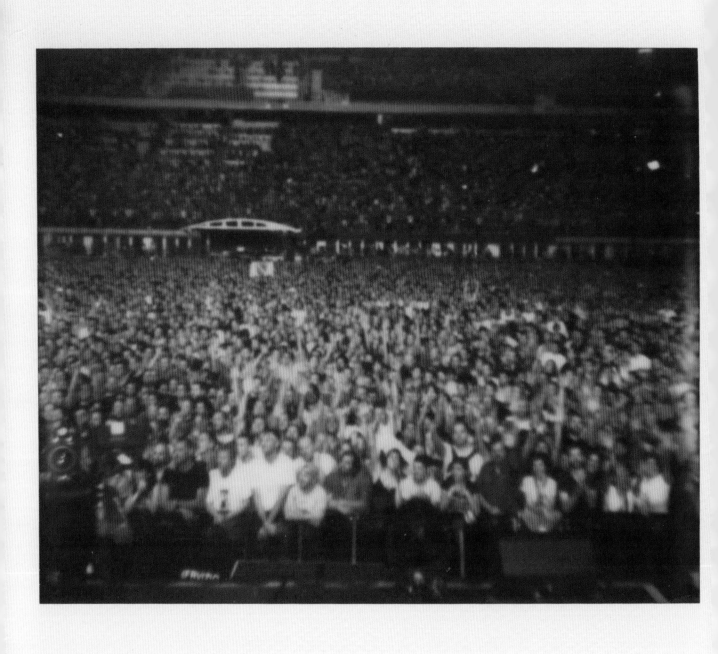

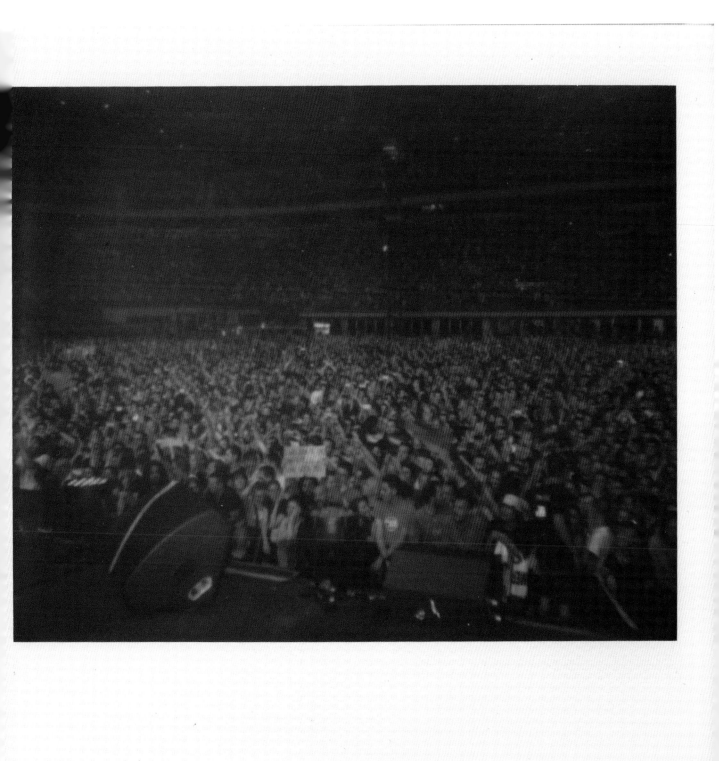

227

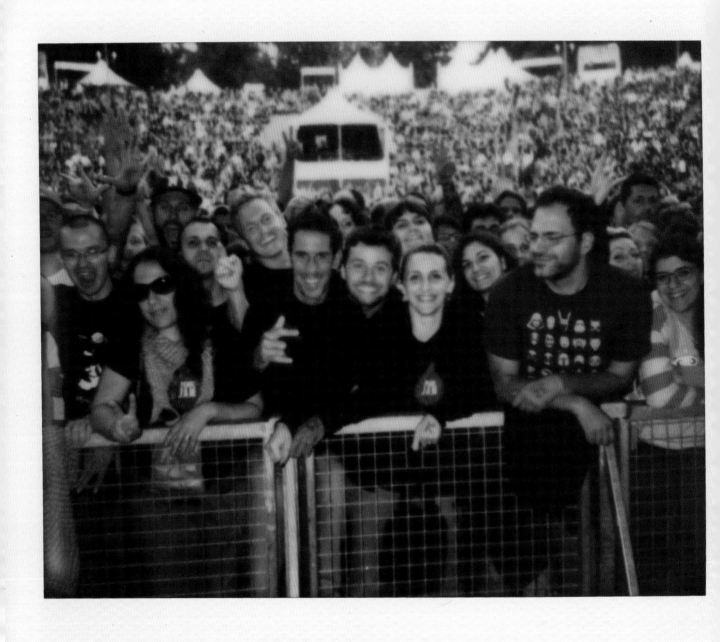

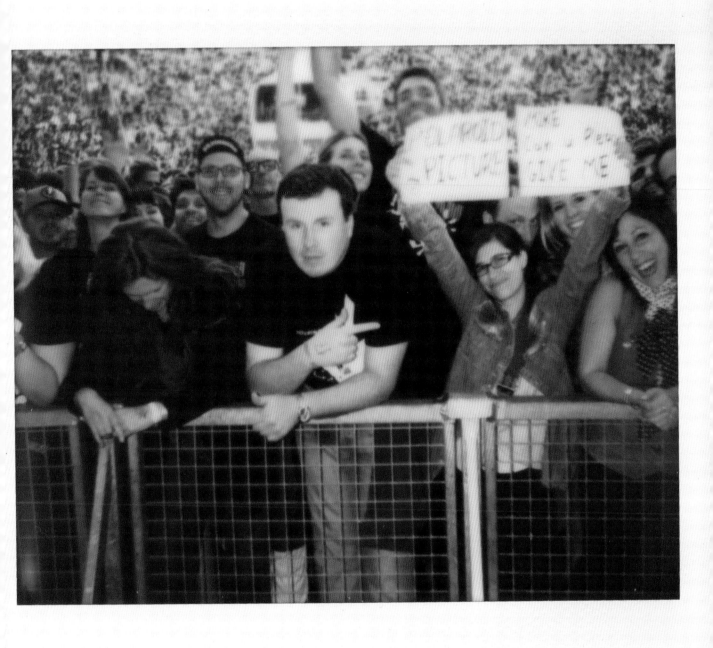

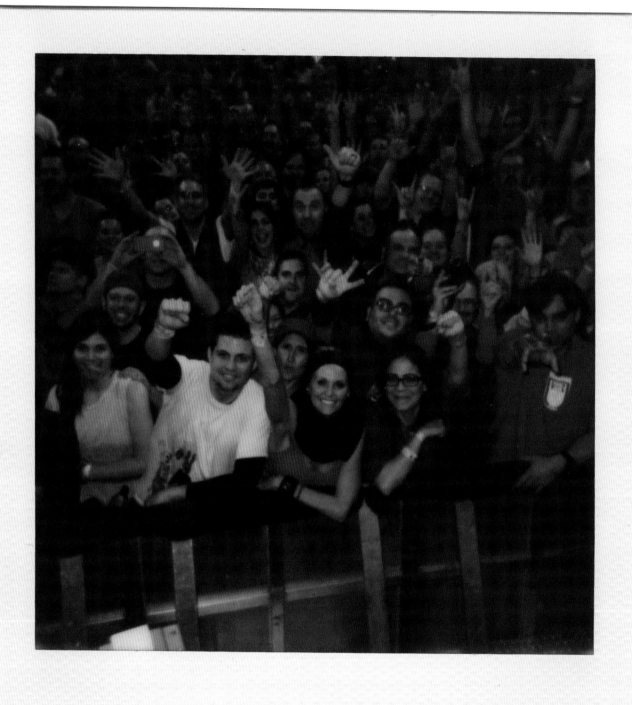

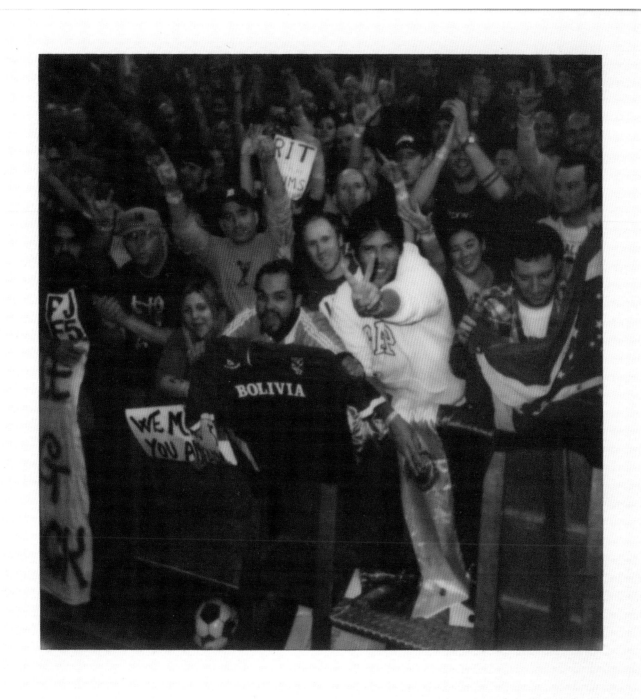

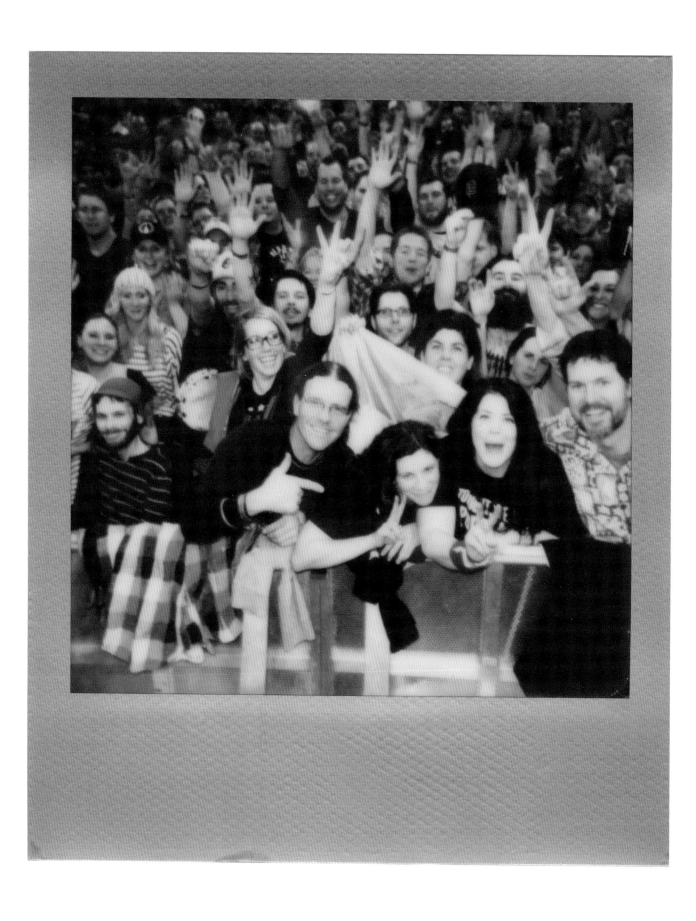

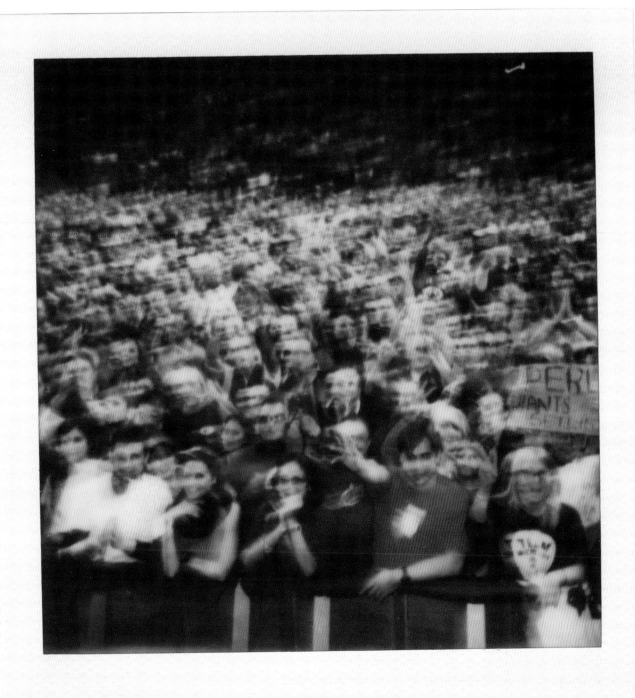

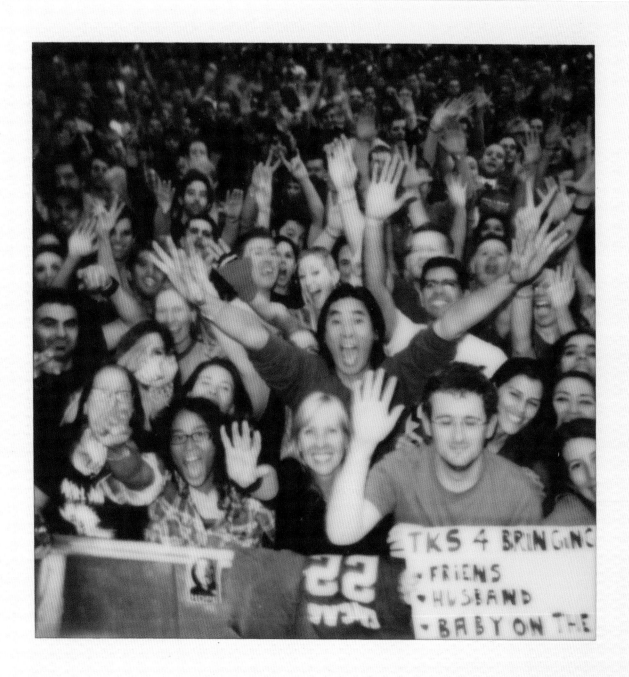

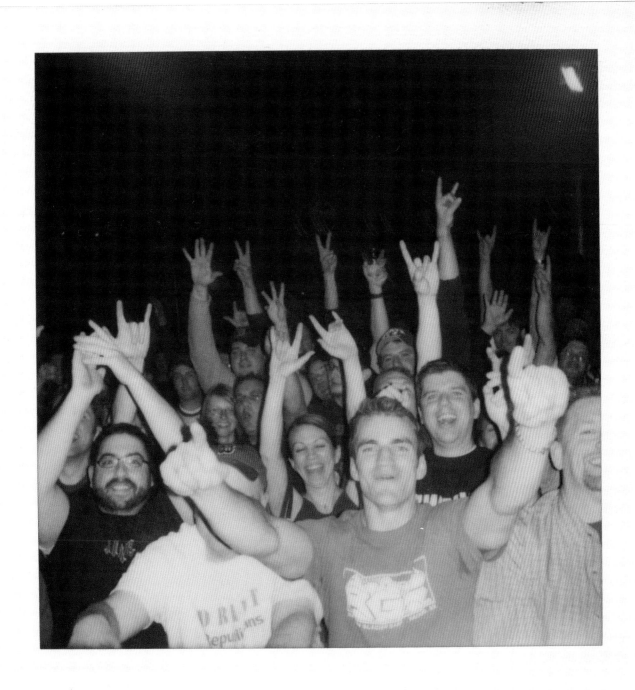

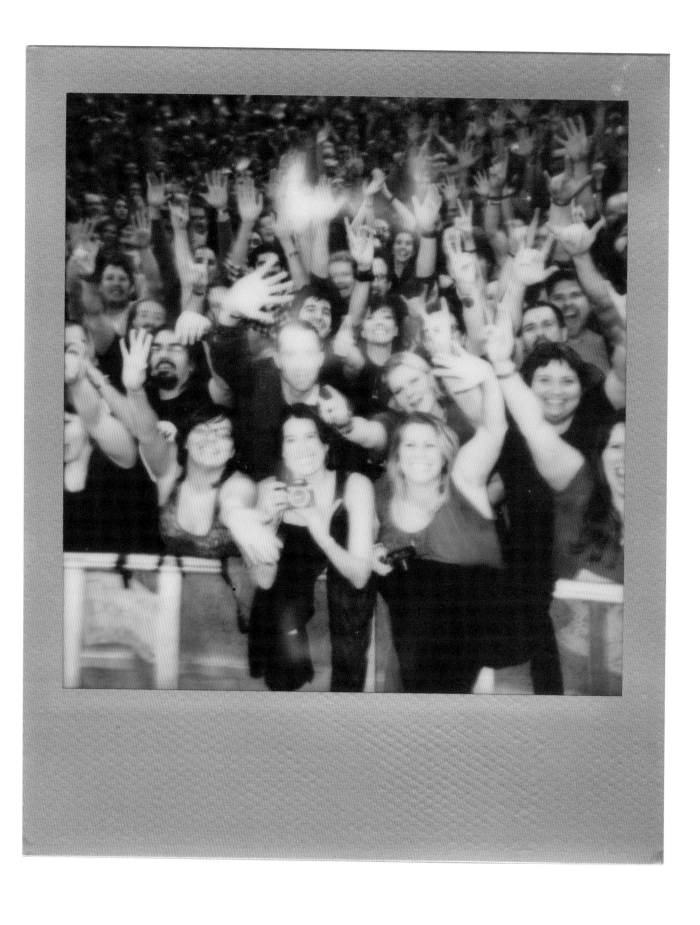

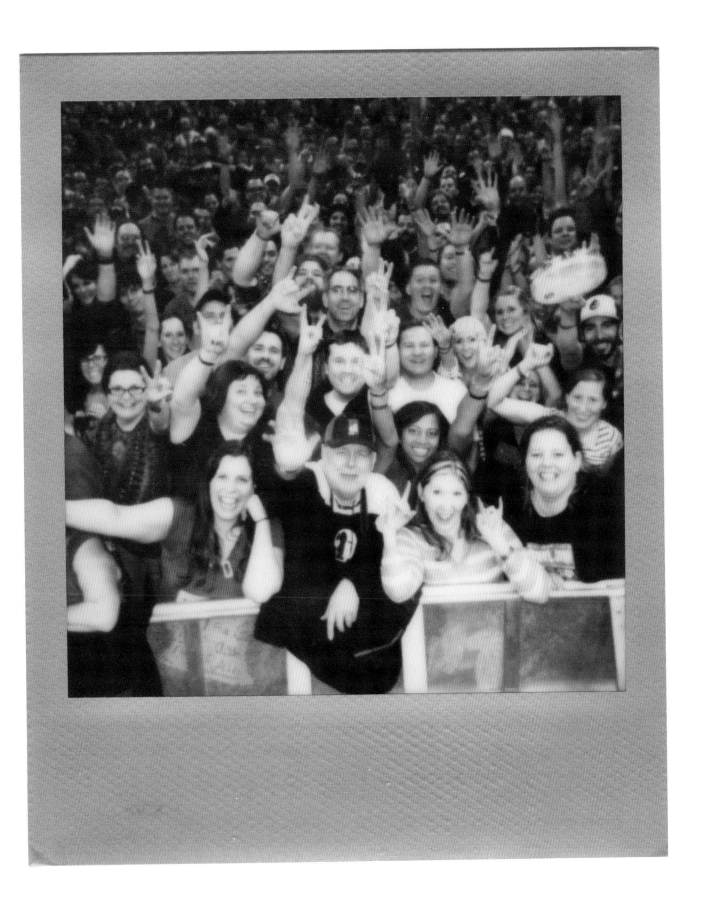

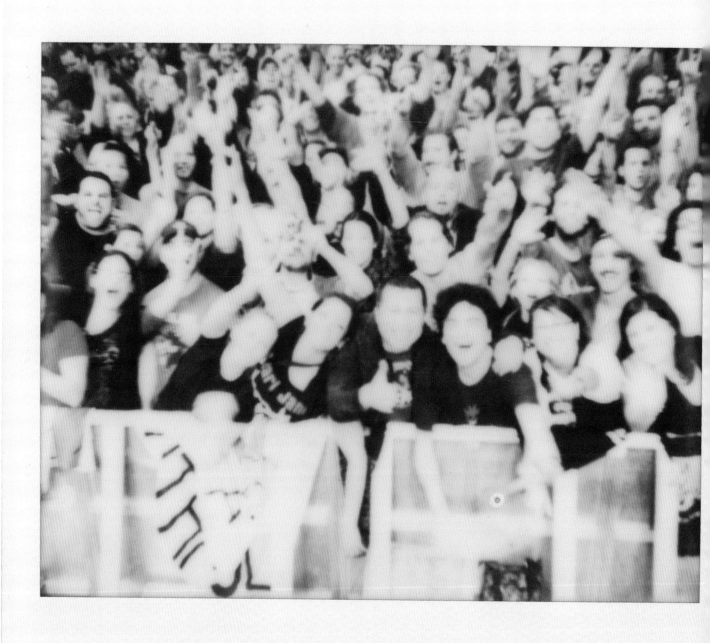

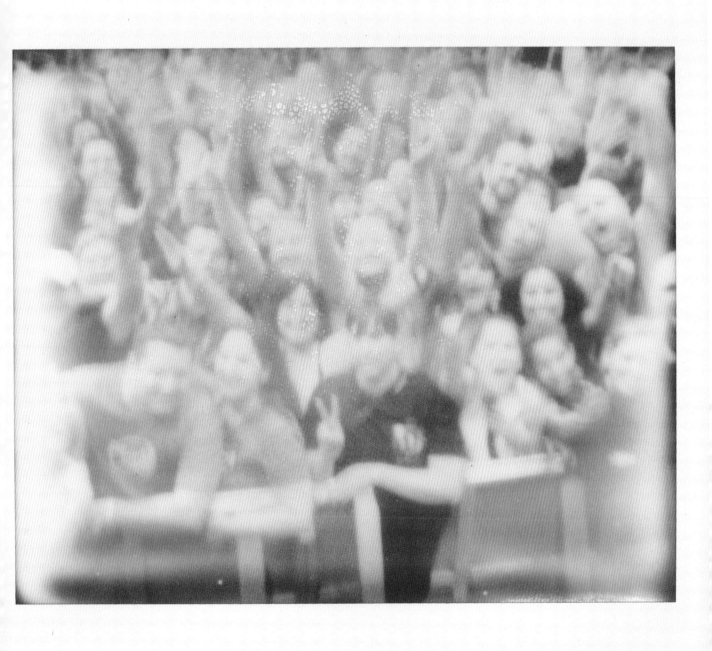

Of Potato Heads and Polaroids:
My Life Inside and Out of Pearl Jam

Published in the United States by powerHouse Books,
a division of powerHouse Cultural Entertainment, Inc.
37 Main Street, Brooklyn, NY 11201-1021
telephone: 212.604.9074
e-mail: info@powerHouseBooks.com
website: www.powerHouseBooks.com

First edition, 2017

Library of Congress Control Number: 2016962998

ISBN 978-1-57687-835-4

10 9 8 7 6 5 4 3 2 1

Photographer / Author / Editor • Mike McCready
Layout / Design • Regan Hagär
Production Assistant • Erin Buell

Additional Photography by
•
Danny Clinch
Lance Mercer
Chris Adams
Jack White

Thank you to my mom who always encourages my love of music and art.
To my dad who gives me insights into life and nature.
To my wife Ashley who is my world and made me a better person.
To Kaia, Jaxon, and Henry for inspiring me.
Finally, I need to thank Ed, Jeff, Stone, and Matt for the incredible
journey of music and life with Pearl Jam.
I am humbled by our success always!

Thank you to:
Kelly Curtis
Chris Adams
Christian Fresco
Jessica Curtis
Sarah Seiler
Craig Cohen
Will Luckman
Michele Bernstein
Dorian Karchmar
Elliot Groffman
Paul Gutman
Rare Medium Cory Verellen
Glazers Camera thanks Becca!!